GOOD VIBRATIONS®

The New Complete Guide to Vibrators

Revised 4th Edition

Joani Blank
with
Ann Whidden

Foreword by Betty Dodson

*Being a Treatise on the Use of Machines in the
Indolent Indulgence of Erotic Pleasure-seeking,
Together with Important Hints on the Acquisition,
Care and Utilization of Said Machines, and Much
More about the Art and Science of Buzzing Off*

Down There Press
San Francisco, California

Copyright ©1982, 1989 Joani Blank
Copyright © 2000 Joani Blank and Ann Whidden
Illustrations pp. 1, 3, 5, 9, 11, 12, 13b, 17, 21 © 1982 by Marcia Quackenbush
Additional illustrations by Jennifer Wong and Mariane Zenker, © 2000 by Open
Enterprises Cooperative, Inc.

Library of Congress Cataloging-in-Publication Data
Blank, Joani, 1937-
Good vibrations: the new complete guide to vibrators / Joani Blank, with Ann Whidden;
Preface by Betty Dodson.-Rev., 4th ed.
 p. cm.
"Being a treatise on the use of machines
Includes bibliographical references.
ISBN 0-940208-26-1 (pbk.)
1. Masturbation. 2. Vibrators. 3. Female orgasm. I. Whidden, Ann, 1969- II. Title.

HQ447 .B54 2000
306.77'2-dc21 00-023543

We also offer librarians an Alternative CIP prepared by Sanford Berman, which may more
fully reflect this book's scope and content.

Alternative Cataloging-in-Publication Data
 Blank, Joani, 1937-
 Good vibrations: the new complete guide to vibrators. By Joani Blank with Ann
Whidden. Preface by Betty Dodson. Revised 4th edition. San Francisco, CA: Down There
Press, copyright 2000.
 "Being a treatise on the use of machines in the indolent indulgence of erotic pleasure-
seeking, together with important hints on the acquisition, care and utilization of said
machines, and much more about the art and science of buzzing off."
 Includes material on Ben-Wa balls, anal stimulation, the G-spot, and vibrator use by
women, men, and couples.
 1. Vibrators. 2. Vibrator use. 3. Masturbation. 4. Sex manuals. 5. Ben-Wa balls. 6.
G-spot. 7. Women—Sexuality. 8. Men—Sexuality. 9. Anal sex. I. Title. II. Title: Vibrator
guide. III. Title: Buzzing off. IV. Whidden, Ann, 1969-. V. Down There Press.
 612.6

Cover illustration: MB Condon
Cover production artist: Jennifer Wong
Page layout and design: Small World Productions

Additional copies of Good Vibrations are available at your local bookstore or directly from
the publisher:

Down There Press, 938 Howard Street, #101, San Francisco CA 94103

Please enclose $13.45 for each copy ordered, which includes UPS shipping and handling.
California residents please add sales tax.

Visit us online at www.goodvibes.com/dtp/dtp.html

Printed in the United States of America 10 9 8 7 6 5 4 3 2 1

Table of Contents

Foreword to the 3rd edition, by Betty Dodson v

Introduction: Once Upon a Time.... vii

1. The "Hysterical" History of the Vibrator 1
 Old vibrators

2. Plug it In, Rev it Up: Electric Vibrators 7
 Coil-operated vibrators ◆ Wand vibrators ◆ Swedish
 massagers ◆ Rechargeables ◆ Variable speed

3. Pleasure without Outlets:
 Battery-Operated Vibrators 17
 Why choose a battery vibe? ◆ What they're made of
 ◆ Hands-free vibes ◆ Sidebar: Ben-Wa Balls ◆ Twice as nice
 ◆ Remote-controlled vibrators ◆ Sidebar: Vibrator? or
 Dildo? ◆ Waterproof vibrators ◆ Vibrating eggs

4. More Buzz for the Buck: Buying a Vibrator . . . 29
 Stores ◆ Mail order catalogs ◆ On-line shopping
 ◆ Home parties

5. If It's Your First Time 35
Doing what feels good ◆ Using a vibrator for anal/rectal
stimulation ◆ Sidebar: Give Yourself a Hand! ◆ Care and
feeding of your vibrator

6. Women and Vibrators 41
If you've never had an orgasm ◆ Sidebar: Stand Up and
Be Counted! ◆ If you get aroused easily, but can't get over
the top ◆ Vaginal vibration and the G-spot ◆ Sidebar: Give
Yourself a Squeeze – PC Exercises

7. Men and Vibrators . 49
Toys exclusively for men

8. Just the Three of Us: Vibrators and Partner Play 55
Adding a vibrator to harness play

9. But What About...?
Questions, Concerns and Tips 61
Water and vibrators ◆ Vibrators: who's the boss? ◆ But
my therapist said... ◆ You're in control ◆ Vibrators and
disability ◆ Health considerations and special uses

10. And She (or He) Buzzed Happily Ever After . . 71

About the Authors . 73

Selected Reading . 75

Foreword to the 3rd revised edition

AFTER TWENTY-THREE YEARS of using an electric vibrator, I am still discovering new experiences with pleasure and orgasm. In the beginning I admit I was a bit worried about walking off into the sunset with my electric friend in hand, never to be heard from again. But since I have continued to also enjoy "people sex," I have finally stopped worrying about becoming vibrator addicted. I've neither worn my clitoris down to a nub nor become antisocial.

As a sex teacher I have taught the use of the electric vibrator for selfloving to thousands of women who have taken my Bodysex workshops, or who have read my book *Sex For One: The Joy of SelfLoving*. For the pre-orgasmic woman, an electric vibrator is heaven-sent. This strong, consistent and reliable form of stimulation can re-establish the connection of the nerve pathways from the clitoris to the brain. Women in their thirties, forties, fifties and beyond can discover erotic feelings after a lifetime of sexual repression, sexual deprivation or lack of sexual interest. Sexual energy is healing.

Some women say they don't need a vibrator because they have a loving partner who gives them all the orgasms they want. There is no rule that says a woman must use a vibrator to be fully sexual. But over time, monogamy and marriage tend toward boredom, and that's when vibrators and other sex toys can be introduced for sexual variety. Whether it comes from a lover, a finger, a dildo or a vibrator, an orgasm is an orgasm is an orgasm.

Orgasms come in many colors, textures, sizes and forms of pleasure. For me there is no such thing as a "bad" orgasm. I love

the happy little orgasms I get from a fifteen-minute sex break. At the other end of my scale are the intense orgasms that are part of a two-hour selfloving ritual with my electric vibrator and a dildo. It's a cosmic flight of joy—breathing, rocking, riding the waves of ecstacy. My electric orgasms put me in touch with my sexual and spiritual power as I become one with the goddess of love.

Joani Blank has been a pioneering sex counselor and educator, breaking ground in the field of female sexuality with her own books, her vibrator store and her publishing company. Our ongoing exchange of information has enriched both of our efforts to better understand our own, and other women's, sexuality. Joani has enhanced the erotic lives of millions of women and their partners.

First published in 1977, Good Vibrations is a classic in its field. It has a wealth of information about sexuality and orgasm as well as vibrators. Since electric orgasms are still relatively unknown, this book is a must for women and men who want to explore sexual pleasure in depth.

—*Betty Dodson*
Summer, 1989

Author's note: Betty says very little about men in this foreword, but I know for certain that she thinks all this stuff applies to them too.
—*J.B.*

Introduction

Once Upon A Time...

In 1976...

I WALKED A FEW TIMES past the department store salesclerk who was eagerly demonstrating the big blue and white massager, "On sale today—only $19.50," she said. Although I had heard about sexual uses for electric vibrators, I couldn't justify spending twenty dollars (hey, it was 1972!) just to try the massager for masturbation. So I turned my back and asked her to hold the whirring machine to a chronically tight spot on my right shoulder. The massager was stronger than any other I'd ever felt. The low speed produced a deep throbbing sensation. The high speed was so fast it either tickled or hurt, depending on how it was touching me. It hurt my shoulder so good that I bought it without further hesitation. It didn't even occur to me to try masturbating with it for several weeks.

Up until then, the only way I had masturbated was with my hand, occasionally using an object in my vagina at the same time. I had inserted the handle of my electric toothbrush into my vagina, enjoying the gentle vibrations and warmth, but I hadn't thought to use it on or near my clitoris. Within moments after I held the new blue and white vibrator to my clitoris, I experienced the most intense orgasm of my life. Although it was all over before I knew what was happening, I saw great potential for pleasure in my new toy.

My partner and I, being yard sale and flea market fanatics, started to collect antique and just plain old vibrators and massag-

ers at every opportunity. After a couple of years, we had acquired more than thirty treasures. At first, I tried masturbating with every one and found, to my delight, that all of them, regardless of size, shape, or intensity of vibration, gave me orgasms. We kept them amid the jumble of their own cords and loose attachments in a fabric suitcase under our bed. Periodically we would haul out the suitcase, untangle a few, and plug them in for our friends to giggle or marvel at. Some went out on loan and never returned.

In 1977...

In the seventies, I was being trained as a sex therapist and was working with many women who had never experienced orgasm. The women in my groups who wanted to experiment with vibrators expressed distress about how awkward they felt purchasing them. Shortly thereafter, in 1977, I decided to open Good Vibrations, a vibrator store especially (though certainly not exclusively) for women, with a vibrator museum (actually an antique oak showcase) for the public display of our collection. I also wrote and published the first edition of this book.

In 1989...

Since then, I have learned a great deal about vibrators. In the store, I've had the opportunity to talk with hundreds of women and dozens of men about all aspects of vibrator use. During the past several years, people have become more comfortable talking about vibrators. Sales of vibrators in drug, department and discount stores have mushroomed, though advertising and promotion are still aimed at consumers' sore muscles and tired feet. However, once many of these vibrators get home and out of the box, they probably spend at least some of their turned-on moments turning someone on. People are certainly using vibra- tors much more; however, vibrator use is still shrouded in secrecy

and embarrassment for the majority of Americans, as is just about every other aspect of our sexual expression.

In 2000...

Good Vibrations, which celebrates its 23rd anniversary in the year 2000, has grown dramatically during the last two decades. There are now stores in both San Francisco and Berkeley, California, and a large mail order operation fueled by an award-winning Web site and catalog. Dozens of stores espousing an approach to vibrator sales similar to that of Good Vibrations have sprung up around North America.

I was recently called by an earnest journalism student inquiring if she could ask me a question about Good Vibrations. Since I was otherwise occupied at the time, I asked if she had a big or a little question, thinking that if it were the former, I'd schedule a phone conversation with her for later in the day. Without responding to my "big or little" query, she said, "What I want to know is how sexuality in America has changed since you started Good Vibrations in 1977." I couldn't resist asking her if she thought this was a big or a little question, and I guess it is a tribute to contemporary American schooling that she was very quick with the correct answer.

I won't even start to tackle her question here, but I do want to say a few things about vibrators and the American way of sex here at the dawn of the new millennium.

From time to time I feel a little concerned that the "more/faster/stronger/bigger/better" ethic that pervades our society today supports and is supported by the use of vibrators in an unfortunate way. In other words, it bothers me that a woman may become a vibrator enthusiast primarily because the vibrator affords her faster, stronger and perhaps many more orgasms, instead of because using the vibrator frees her from dependence on a partner or because it further enhances an already satisfying sexual relationship.

Certainly, people are talking even more openly about many aspects of sexuality than they were just ten years ago. The tremendous increase in our ability to communicate electronically (both personally and commercially) has impacted talk about sex, perhaps more dramatically than "talk" about any other subject. In cyberspace, the wall between public and private spheres softens while those who still require complete anonymity can have it.

Vibrators appear more frequently in print as well. For example, it wouldn't surprise most people today to see an article about vibrators in one of the mainstream women's magazines, alongside others on how to catch a boyfriend, or how to get the one you have to give you whatever it is you want. I believe that today, a good number of men whose wives or girlfriends are enjoying vibrators have made their peace with those vibrators, and many have come to appreciate or celebrate how much pleasure their lovers are deriving from using the vibrator. In many such cases this is because the women have themselves become both more adventurous and more relaxed about their sexuality in general, and about vibrator use in particular.

It's my impression that there are fewer stupid vibrator jokes around (as well as a few more really great ones). And there are other indications that the whole topic of vibrators and other sex toys is slowly but surely leaking into the mainstream. Vibrators are being mentioned in popular movies and featured in TV sitcoms. More women are unashamed to acknowledge that they rarely, if ever, leave home without theirs. To my way of thinking the most important recent development is that people are finally beginning to recognize that most women prefer clitoral to vaginal vibration, so that the non-cylindrical plug-in vibrator is finally taking its rightful place in the lineup of choices we have.

In just the last three or four years, the range of new vibrators appearing on the market has broadened considerably. Many more can be used in a harness, some have a remote control, some clip onto a fingertip and are powered by watch batteries, and some are in brand new shapes, colors and textures. In preparing this edition of *Good Vibrations*, I had the distinct pleasure of working

with Ann Whidden, a longtime Good Vibrations staffer who has much more information about these additions to the repertoire than I do. I thank her for her substantial contribution.

The first time I did an autographing of this book at a book-seller's trade show, I signed most books with the phrase, "Enjoy yourself, it's earlier than you think," or, if they told me they'd never tried a vibrator, I'd write, "You are in for a treat." And I didn't mean reading this book. So, dear reader, please take whichever of these fits as my personal message to you.

—*Joani Blank*
Oakland, California, January 2000

1

The "Hysterical" History of the Vibrator

D ID YOU EVER WONDER what mysterious ailment confined the Victorian woman to her bed? Our prim and proper ancestor had the doctor scurrying up the stairs with his little black bag and the servants whispering about "female troubles."

Not infrequently, those "female troubles" were "hysteria," believed in ancient Egypt and Greece to be the revolt of the uterus against sexual deprivation. *Webster's* reminds us that hysteria derives from "the former notion that hysteric women were suffering from disturbances of the womb" (now you know why men are almost never hysterical!) and defines it as a "psychoneurosis marked by emotional excitability and disturbances of the psychic, sensory, vasomotor and visceral functions." It wasn't until 1952 that the American Psychiatric Association dismissed hysteria as a valid diagnosis.

In 1989, historian Rachel Maines provided us with a wealth of information about the standard medical treatment of "hysteria" using vibrators. Her article, delightfully titled "Socially Camouflaged Technologies: The Case of the Electromechanical Vibrator" was published in the journal

Technology, not in a journal about medicine or sexuality. Maines shows that the electromechanical vibrator, introduced as a medical appliance in the 1880s and as a household appliance between 1900 and 1905, represented a de-skilling and capital-labor substitution innovation designed to improve the efficiency of medical massage, a task performed since ancient times by physicians, midwives and their assistants. Medical massage "from the time of Hippocrates to that of Freud included the clinical production of orgasm in women and girls."

In 1998, Johns Hopkins University Press published Maines' fascinating book *The Technology of Orgasm: "Hysteria," the Vibrator, and Women's Sexual Satisfaction*, in which the author delves more extensively into the phenomenon which she first documented almost a decade earlier.

According to medical and midwifery texts of the 1600s, the treatment for "hysteria" generally consisted of "the insertion of one or more fingers of one hand into the vagina and the application of friction to the external genitalia with the other. Fragrant oils of various types were employed as lubricants in this procedure." The objective was to induce "hysterical paroxysm," manifested by "rapid respiration and pulse, reddening of the skin, vaginal lubrication and abdominal contractions." Sounds very familiar, doesn't it, but at the time it was considered an activity more appropriate to the doctor's office than the boudoir!

Maines writes that not all physicians recognized this "paroxysm" as an orgasm, but some medical authors through the ages did "comment on the morally ambiguous character of the treatment, including [one physician] who observes that genital massage should be reserved 'to those alone who have clean hands and a pure heart." Later therapies included massage with a jet of water, but "hydrotherapists warned that patients were inclined to demand more treatment than was considered good for them." A seventeenth-century doctor complained of the fatigue factor for the physician in massage therapy and the long practice and considerable dexterity required (not to mention the stress of keeping those hands clean and those hearts pure).

Maines credits George Taylor, an American physician, with a primary role in the development of the modern vibrator in this country. In 1869 and 1872 he patented a steam-powered massage and vibratory apparatus for treatment of female disorders, intended for supervised use "to prevent overindulgence." By 1900, "a wide range of vibratory apparatus was available to physicians....Articles and textbooks on vibratory massage technique at the turn of the century praised the machines' versatility for treatment of nearly all diseases in both sexes, and its [sic] efficiency of time and labor, especially in gynecological massage....By [1909] convenient portable models were available, permitting use on house calls...." (So now we know what was inside the doctor's little black bag.)

Until the end of the 1920s, vibrators were advertised in many respectable women's magazines as home appliances, primarily as an aid to good health and relaxation, but with ambiguous overtones. "All the pleasures of youth will throb within you," reads a typical advertisement. Maines theorizes that the disappearance of vibrators from doctors' offices and magazine advertisements "may have been the result either of the adoption of psychotherapeutic treatments [for hysteria] by physicians, or of the appearance of vibrators in stag films in the Twenties, or both."

Many of the electric vibrators discussed in *Good Vibrations* were not designed with sexual uses in mind. And they're still not marketed for sexual use. The fitness craze of the '90s has, however, brought massage vibrators into the homes of many people who might otherwise not have owned one. It's very likely that a number of those vibrators have, at least on occasion, strayed from tired and tense muscles in the back, arms and legs.

In a 1981 *Esquire* article, author Mimi Swartz reviewed the emergence of the vibrator as a big business venture, with sales total-

ing about $13 million in 1980. This is a remarkable story when you consider that the manufacturers were marketing a product without advertising its main benefit. Imagine trying to sell a toaster by saying that it is a metal box that gets very hot when you plug it in, and that's all. Apparently this non-existent marketing approach failed, since several mainstream manufacturers of personal care products stopped manufacturing vibrators a few years later.

Electric vibrators/massagers have been manufactured in the United States since around the turn of the century (the most elderly in my collection was made by Hamilton Beach and carries a patent date of 1902). However, the first electric vibrator openly advertised for sexual use was an American-made, multi-attachment model, repackaged in the early '70s with a clitoral stimulator tip, and sold at first almost exclusively through the mail. This particular brand is now sold primarily by discount stores alongside the hair dryers and electric toothbrushes. The package insert is pretty tame; all sexual references have disappeared. At the beginning of the millennium, a well-stocked department or discount store in some parts of the country may carry as many as four or five different brands of electric vibrators, and lest rural readers despair, personal care products catalogs often include a line of good quality vibrators.

Some companies that manufacture multiple-attachment massagers have tacitly acknowledged that at least some of their customers might use the products for sex, by including among the attachments one for those special, hard-to-reach spots. But generally, mainstream manufacturers of personal care products publicly deny the sexual uses of their wares; one even cautions, "Do not use on genital areas of the body." I once met a woman who had purchased a vibrator on the specific recommendation of her sex therapist. Needless to say, when she read this warning, she was a bit distraught, and I can't blame her. Frankly, I'm not clear just what this company is trying to protect its customers from. They obviously don't want to acknowledge that thousands of women and increasing numbers of men use or intend to use their products for sexual stimulation.

Interesting, isn't it, that vibrators which lost their respectability when they were shunned by the medical profession are now seen as an important tool for women taking control of and enhancing their sexuality.

Old vibrators

Most of the old, second-hand, used or antique vibrators you might find at thrift stores, flea markets and garage sales are electric, not battery-operated. Some of the oldest are huge and heavy, while others are amazingly compact. If the case is not cracked or the motor inside is not loose, they are often very quiet. One oldie, with a metal case and screw-on attachments, is so quiet that you can't tell whether it's on unless you're holding it. Old vibrators come in all shapes and sizes. We have one which closely resembles an old electric drill without the drill bit; another has six little, plastic vibrating feet and looks like a cross between a 1950s automobile and a miniature submarine. Although it's about forty years old it has four "speeds."

Most older, multi-speed vibrators change intensity with a mechanism that tightens and loosens the vibrating head. The motor itself does not run faster and slower. Some of the very old machines don't even have an on-off switch; it's on and you're off! As to cost, ours have ranged from $3.00 to $10.00. Others sell for as much as $25.00-$30.00. If you are going to buy a used vibrator for anything other than a good laugh, plug it in to be sure it works before you hand over your money. Usually they are not worth repairing. Of course, if the cord is frayed or if anything is obviously loose inside, you may not even want to plug it in for fear of an electric shock.

2

Plug it In, Rev it Up:
Electric Vibrators

IN GENERAL, ELECTRIC VIBRATORS are strong, quiet and
well-made by brand name electrical appliance companies that
do not acknowledge the sexual pleasure potential of their
products. An electric vibrator will last for years, it will not elec-
trocute you as long as you keep it out of water and it is well
worth the investment and trouble of an extension cord if your
bedroom outlet isn't handy. Any vibrating toy that plugs into
the wall is considered an electric vibrator, but you also might
hear them called either coil-operated or wand (also known as
"motor-driven") vibrators.

Electric vibrators are most popular for external stimulation—
on the clitoris, penis, testicles or wherever else you can think
of—because the vibrating head (or vibratode, as they were called
in the early 1900s) is generally too large for pleasurable penetra-
tion in the case of wand vibrators, and too small in the case
of coil-operated vibrators. You can buy separate attachments to
adapt your electric vibe for inserting into the vagina or anus,
but they measure only about four to five inches long, and are a
slender 3/4" in diameter. Still, when it comes to strong, consistent
clitoral or other external stimulation, the electric vibrator can't
be beat!

Since the vibrator revolution started with coil-operated devices,
I will describe them first. These are the vibrators that twenty

to twenty-five years ago were most likely to be available in a discount or department store. Now motor-driven wands are commonly found there as well.

Coil-operated vibrators

"The pleasure was so intense it terrified me and I remember telling him I wasn't so sure I liked the mechanical aspect of this machine. He asked me if I wanted him to stop and I wisely said 'no'."

– Betty Dodson in *Forum*

A coil-operated vibrator is shaped somewhat like a small hairbrush or hair dryer with the vibrating head at a right angle to the handle. Inside it is an electromagnetic coil, not a motor. The vibrating post (over which plastic attachments are slid) is mounted on a piece of flat metal at the end of the coil. When the switch is on, it vibrates at 60 cycles/second, the "speed" of the electrical current in the wall.

The "high speed" is actually half that fast (about 30 cycles/second), but the vibration feels stronger because the attachment has a longer time to move in each direction and thus moves farther.

Coil-operated vibes are also almost completely silent, even from just a few feet away—great news for those with children, roommates or very thin walls.

Coil-operated vibrators come with four to six plastic attachments of varying flexibility. These are designed for massaging different parts of the body, but you will probably find one or two favorites to use on your genitals.

Almost all of these vibrators are packaged with at least one attachment well suited for clitoral stimulation. Additional

attachments are available from companies that sell sex-related items. One is what we at Good Vibrations call a Clitickler, a knob-like attachment similar to those now packaged with most brand-name coil vibrators.

Several four-to-five inch insertable attachments are also available. Exercise caution when using these for internal stimulation; since they sit on a short shaft, they can wobble loose with only a little side-to-side pressure. Although the attachment cannot get "lost" in the vagina, the shaft on which it is mounted may become hot if the vibrator has been running a while. And because it can pop off relatively easily, this style of attachment should never be used for anal stimulation.

Also very popular are the Twig and the Come Cup. The Twig is designed for simultaneous clitoral and vaginal stimulation. Some women rave about it, while others are disappointed when they try it. The designer had to choose one length and angle for the two tips of the Twig, and that seems to be just right for some women. For others, though, if the longer tip is in the vagina at a comfortable or pleasurable angle, the shorter one is nowhere near the clitoris. The Twig is safe for anal use, because the smaller branch will insure that it won't slip into the anus.

The Come Cup is a tulip-shaped attachment designed for stimulating the end of the penis. Reviews of this item are also mixed. Some men find the stimulation too intense if the vibrator touches the glans directly, and a few report that the slits that separate the "petals" can pinch if the cup is held around the glans too firmly. On the other hand, some men say the Come Cup lives up to its name very admirably—particularly if a thick, water-based lubricant is used to combat pinching. Oil may be used as well with this attachment, if it is the preferred masturbation lubricant of the user.

A few manufacturers make a coil-operated vibrator that has a heat attachment, or a heat setting. We steer people away from using heat vibrators for sex because they can easily cause minor burns on tender genital tissue. In addition,

especially since these vibrators are generally very quiet, the user might fall asleep with the hot vibrator touching some part of his or her body.

If a coil vibrator starts to make noise it is usually because the attachments have started to get a little loose. Putting a small rubber band around the metal or plastic shaft and pressing the attachment over it will often solve that problem. If there is no attachment on the shaft when you turn the vibrator on, it will probably be extremely loud. This can be cause for great amusement if the attachment should pop off while you are using the vibrator. If your coil-operated vibrator makes a really loud noise with an attachment in place, it is singing you its swansong, and needs to be replaced. The coil assembly has usually come loose from the case, or it is fatally injured in some other way.

Wand vibrators

First reactions to the large wand-type vibrator range from "My God, it's so big!" to "So this is what everyone is raving about." The wand-type vibrator, of which the Hitachi Magic Wand is still the most popular, has a long cylindrical body or handle and a ball-shaped vibrating head attached to the body by a flexible "neck." The two-speed electric motor is attached to a thin shaft which goes up through the neck into the head. At the top of the shaft, inside the head, is a triangular piece of metal called an off-center or eccentric, which spins and causes the vibration. Because the small motor has moving parts, this kind of vibrator makes a whirring sound.

Wand vibrations are large and slow in comparison to those of the coil-type vibrator. Coil-types actually produce a much smaller, but faster, vibration; that is, the distance the head moves back and forth is much smaller. The amplitude or size of the vibration, not the frequency or speed, seems to be the quality which leads most people to prefer the wand-type vibrator for massage. They say the vibration is deeper, or stronger. In addition, the relatively larger

surface of the vibrating head spreads out the sensation, making the wand preferable for both massage and sexual use.

Some women using the wand-type vibrator experience the relatively slow speed as less driving and not as overwhelming as the faster motion of the coil-type. One woman said simply, "The vibrations of that little guy [coil-type] are just not in sync with my own vibrations. The speed sets my teeth on edge and makes me feel tense instead of turned on." Most women who have tried both kinds of vibrators do not feel nearly so negative about the coil-type; rather, they find that either kind does quite an adequate job.

The ease with which partners can use these two types of vibrators together is also a factor for many in choosing which to purchase. Aside from the way the vibrations feel to both partners, which is the primary consideration, it is also important to take into account the possibilities for positioning or holding the vibrator so that it is comfortable if both people want their genitals stimulated by it at the same time.

The coil-type's smaller size and silence have been touted as making it the best for partners. These are distinct advantages, but there are two disadvantages as well. Maintaining the "right" position and pressure, which is crucial with this kind of vibrator, can be difficult when there are two bodies to manage instead of one and when the vibrating surface or attachment is small. Also, if the couple is in a face-to-face position, someone's hand has to be between their bodies to hold on to the compact vibrator.

The wand-type's advantage is that couples find the ball-shaped attachment fits nicely between two sets of genitals in all positions but the most traditional missionary position. It works well even in that position if both partners are women. In face-to-face positions, the handle of the vibrator can lie in the groin crease, and be held or moved by any hand that isn't squished between two bodies.

There is an additional advantage of the wand-type vibrator or any good massage vibrator when used by couples. If one or both people are new to vibrators and feeling leery about having this

foreign object in bed with them, they can use the vibrator just for massage until they are thoroughly comfortable with it. Because the wand vibrator is so good at soothing tense bodies, it is an ideal gift for a person who might get a bad attack of performance anxiety if faced with a "sexual-use-only" vibrator.

Both wand-type and coil-operated vibrators can overheat if they are left on for twenty to thirty minutes or more. Those with motors can actually burn out if they are left on for a long time after the handle is hot to the touch. Manufacturers warn you not to run certain vibrators for more than 25 or 30 minutes; it is wise to abide by their suggestion. If your vibrator gets very hot after only 5 or 10 minutes of operation, it is defective and should be returned to the manufacturer (or retired, depending on its age). Some people own more than one vibrator so they can stay hot while one of their vibrators cools off.

The Hitachi Magic Wand has been Good Vibrations' best seller ever since the doors first opened in 1977. Now, close to a dozen wand-style vibrators are available in North America. Some of these have an angled handle so that a user can more easily reach sore muscles on the neck and back. And a few have a variable speed dial, a nice feature for the user who finds "high" and "low" on the typical wand too limited. Also, the lower speed on most variable speed electric wands is already quite intense, and the high speed is, well....wow. An innovation most appreciated by those who enjoy sex outdoors or where there is no convenient electrical outlet is the rechargeable wand vibrator.

There are three different attachments made specifically to fit the Hitachi Magic Wand and Dr. Scholl's Wand Vibrator—they might fit the vibrating head of a similar wand vibrator, but you should check the fit before you make a purchase. Two of the attachments are quite similar: slender, vinyl shafts that are meant

for penetration and attached to caps that fit over the Hitachi's head. One has a curve to stimulate the G-spot or prostate, while the other is straight. The third attachment consists of a cap that fits over the Hitachi, with an adapter that allows coil attachments such as the Come Cup and Twig to be used with your Magic Wand.

Hitachi and one or two other manufacturers also make a double headed vibrator that isn't wand-shaped. Its two vibrating heads are mounted side by side on a large case shaped somewhat like the coil-types. This vibrator is superb for massaging the back and neck with the heads placed on either side of the spine, and feels very good on tired arms and legs. It is too heavy and very awkward for many sexual uses with two notable exceptions. Some women respond with great rapidity and intensity when the double header is held with one head pressing on the clitoris and one at the anal opening or one on the clitoris and one on the pubic mound at the same time. And some men say the double-header is the perfect masturbation vibrator. All one has to do, they claim, is place the penis between the vibrating heads and hold on for dear life.

Swedish massagers

In the same way the word vibrator conjures up a white, hard plastic phallus in many people's minds, the word massager often makes people think of the heavy, squat machine strapped onto the back of the hand, the so-called Swedish massager. Some men know about these from visits to barber shops where the Swedish massager is used for neck and shoulder massage. Both men and women often say that this is the kind Aunt Milly or dear old Granddad kept around. In fact, some of my most aged antiques are of this type.

My impression is that very few women use this kind of

vibrator for solo sex. Some men find that putting the vibrator on the hand they usually masturbate with enhances the experience; a few are very attached to this way of masturbating. A small number of these men have difficulty coming to orgasm without the vibrator. Swedish or back-of-the-hand massagers allow you to touch your genitals with warm, presumably sensitive hands instead of cold plastic or rubber. And, the vibrations that get through your hand are relatively gentle. However, these are the only advantages.

The disadvantages are that these massagers are quite heavy, the vibration shakes your hand into numbness within just a few minutes, and the spring-like straps have been known to catch pubic hair and do other pinchy things. In summary, a Swedish massager is fine for massage, and can be nifty for sex, too, if the hand that's holding it is not your own.

Rechargeables

What do you do when you've fallen in love with your electric vibrator and the lights go out, or you go camping for the night, or you move your bed across the room and that darned cord just won't reach? Well, you could try a rechargeable vibrator. Most of them are made by the same people making electric vibrators, so they're well-made, long-lasting, and provide strong vibrations, too. There are some made by smaller companies, but if you want a reliable model, stick to better-known manufacturers—many even come with a one-year guarantee.

You are still dependent on electricity, since rechargeable models use an adaptor that plugs into the wall. When it's not being used, you plug it in; usually it takes anywhere from six to fourteen hours to build up a charge. Do check out how long it takes to recharge such a vibrator, and how long it will buzz on a single charge to be sure it will meet your needs before plunking down your money to buy one. Once your vibrator is charged, it should operate happily for about twenty minutes if it is an older model,

and up to an hour if it is newer. Though this one-hour window period is plenty of time for many people to enjoy their toy, some folks do complain that their rechargeable starts to give out at just the moment they're getting going. The especially ingenious simply own two; when one's in use, the other is recharging, so they're never left wanting.

Variable speed

I am often asked what speed of vibration most people like. My impression is that there is no consistency in this matter. Perhaps one day our stores will have little testers on which we can place a finger or hand to find out what frequency is perfectly in tune with each of us; then we can purchase speed adapters for the vibrators. In the meantime, we have to take what manufacturers provide.

Fortunately, there are a lot of choices. Many battery-operated vibrators have a dial or slide mechanism with which the speed can be varied. Although most line-voltage vibrators have two fixed speeds, some of the large wand-style vibrators have a rheo-stat or variable speed dial.

A conventional light dimmer (the kind designed for use with a table lamp) can be used to lower the speed of motor-driven vibrators but not most coil-operated types. However, motor-driven vibrator manufacturers do not recommend using a rheostat because it stresses the motor too much, causing it to wear out more quickly. Some people, however, use a rheostat regularly with a motor-driven vibrator, which suggests that the motor will burn out only if the power is turned so low that the motor lugs or strains.

3

Pleasure without Outlets:
Battery-Operated Vibrators

To some, perhaps most, readers, the word vibrator brings to mind the cylindrical battery-powered vibrator that is more or less phallic. (The "more or less" is dependent in part on the toy's size, shape, texture, and color, and on the interpretation or fantasy of the observer.) This is the vibrator most often seen in cartoons in popular men's magazines, as well as in adult bookstores and catalogs, where it can be found in a glorious variety of sizes and shapes. Many battery-operated vibrators available in "adult" stores and catalogs are designed (rather unsuccessfully, in my opinion) to look and feel like the real thing. They are molded from pliant, pink vinyl or latex, sometimes complete with "veins," and a "glans penis" (head).

Battery vibrators sold in novelty stores and through women's magazines in the forties through the eighties—and still today—were white, hard plastic, of sleek design, and appeared somewhat antiseptic. Used to be that the woman pictured using this vibrator in the little black and white magazine picture or on the flimsy cardboard box was inevitably shown snuggling the vibrator up to her cheek or daringly applying it with a feather-light

touch to her shaven shin. Of course, showing the damsel holding that vibrator anywhere near where it would do any good was out of the question. It would have been in bad taste.

Unfortunately, in part because no instructions (especially none about the sexual use of vibrators) were packaged with this kind of vibrator, many a woman spent hours shoving it in and out of her vagina, wondering how long the batteries would last and why she didn't feel a whole lot. This was not before the invention—oops, discovery—of the clitoris, so it must have been that in those days, women and men shared the notion that a woman's preferred method of masturbation would be simulation of intercourse with a vibrating (or non-vibrating) dildo. Undoubtedly, the shape of the toy contributed to the belief that we were "supposed" to use it internally instead of on the clitoris.

Why choose a battery vibe?

Nothing can beat the strength, durability and reliability of an electric vibe, but battery vibes are smaller and more portable than electrics and they are available in a wide variety of shapes and sizes. Sex toy manufacturers are becoming more responsive to the requests of customers, and new technologies are allowing for smaller, stronger and more unusual toys. So, although I acknowledge some personal bias against battery-operated vibrators, many women use them regularly and happily. They are among:

• Those whose preferred method of self-stimulation is the insertion of, or the movement of, an object in the vagina.

• Those who like vaginal insertion as a secondary kind of stimulation, experienced simultaneously with direct clitoral stimulation. (These women often own more than one vibrator—you can guess why.)

• Those who like a range of vibrations from gentle to strong.

• Those who want a vibrator that is very lightweight, portable and easily concealed.

- Those who enjoy anal or anal-rectal stimulation with a vibrator. (Don't even think about using a vibrator on this part of your body before reading the part of this book that tells you how to do it safely!)
- Those who find that a penis-like object in hand or vagina peps up their fantasies.
- Those who live in rural areas with no electricity or who spend a good deal of their time in the great outdoors.
- Those who wish to enhance their automobile commute time (only while parked or at red lights, please!).
- Those who are fearful of any device that plugs into the wall.
- Those not ready or able to make the financial commitment to a "serious" line-voltage (plug-in) motor- or coil-driven model.
- Those who are given the vibrator by a well-intentioned partner or friend who is committed to the penis-substitute belief or fantasy, not ready to buy the other kind, or simply ill-informed about other options.
- Those who have figured out that just because the vibrator is shaped sort of like a penis, one doesn't have to use it in the way most men enjoy using their penises, that is, by inserting it into a beloved or convenient orifice.

In the last ten years, the people making battery vibrators have become a little more concerned with creating toys that actually do contribute to a woman's pleasure, and so you will find some battery toys that do things electric vibes simply can't: plug into your dashboard, join you in the hot tub, or fit in the palm of your hand. And, since they generally are much less expensive than electric toys, battery vibrators allow you to experiment with different sensations without emptying out your wallet.

What they're made of

Some years ago, when buying a battery vibe, a consumer had two choices of materials: hard plastic, or a softer molded plastic—usually colored a horrific shade of pink called "flesh" (as if any of us actually had skin that color). Today, battery vibrators come in a rainbow of colors, and some revolutionary new materials make them much more comfortable to use.

Hard plastic vibrators are still readily available. Harder materials transmit vibration better than softer ones, so if you desire strong vibration and are using the toy primarily on your clit, you might want to stick with hard plastic. They're not as comfortable for penetration, since they don't have any "give," but they can deliver firm pressure to the G-spot or prostate that other toys can't. Plastic toys are also easier to clean than most other battery vibrators.

Softer molded vibrators are still on the market, but the older materials, plastisol or molded latex stuffed with a cottony material, have been edged out by another plastic material called jelly "rubber." Jelly rubber is quite soft and cushy, making it much more comfortable for use as an insertable toy, yet it still transmits vibrations strong enough for clitoral use for some women. Some jelly rubber toys can be a little floppy if there's not a strong core inside the toy, making it difficult to get any significant pressure with them. So a jelly rubber toy with a harder plastic core inside is the most versatile. Jelly rubber can be a little harder to clean than hard plastic, so using a condom (even if you're just using it by yourself) makes cleanup easier.

A newer material, sometimes called "cyberskin" or thermal plastic, has a quite remarkable texture and resilience. It warms to body temperature quickly—something none of the above-mentioned materials will do—and feels soft and skin-like, while still transmitting vibration very adequately. Products made of or covered with cyberskin are somewhat difficult to clean thoroughly, so it may be a good idea to cover them with a condom, although that does detract from the skin-to-skin sensation they

provide. If you are using a cyberskin vibrator only to pleasure yourself, it is sufficient to wash it with soap and water and let it dry thoroughly between uses. Virtually all microorganisms that can cause trouble in the human body require moisture to flourish, so thorough drying may be the most important part of any hygiene ritual.

Ben-Wa Balls

This isn't really about vibrators at all. But since over the years we've had so many questions about Ben-Wa balls, I will discuss them briefly here. Two kinds of non-vibrating toys, often called Ben-Wa balls, are generally available.

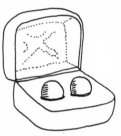

One is a set of $^1/_2''$ diameter gold-plated ball bearings packaged in a pretty little box and accompanied by a good deal of hype. The other kind, sometimes known as Duotone Balls, is a set of larger (1 $^1/_2''$ diameter) plastic spheres attached to each other by a nylon cord for easy removal. Each sphere contains a ½" diameter ball bearing. Without question, the fantasy potential of these devices is substantial for certain people, but...

The smaller gold balls cannot be felt at all by most women except, perhaps, if they are in the vagina during intercourse. It is not true that they roll around inside. Remember, the unaroused vagina is not an open cavern, but a potential space, much like your mouth when it is closed. When the larger hollow spheres are inserted, they do not move either, but gentle movement of the heavy balls inside can be felt if the woman wearing them is doing something very active like jogging or vigorous dancing. The sensation is, at best, subtle. A word of caution: either of these toys can set off the metal detector at the airport. No real problem if they are in your purse or suitcase; big nuisance and embarrassment if they're in your vagina!

It is not easy to sort out the mythology of these balls from the historical reality. My best information suggests that three to four hundred years ago, hollow spheres made of an ivory-like bone were inserted into the vagina by some Japanese women to enhance the experience of intercourse. These balls did not have mercury or anything else inside them; they were rarely, if ever, used for masturbation; they were not used by women in rocking chairs (unknown in Japan at the time); and presumably, used by themselves, they did not produce orgasm.

Hands-free vibes

In the early seventies, when I was working as a sex therapist with women who were just becoming orgasmic, I dreamed up the idea of a battery-operated vibrator which could be used for clitoral stimulation during intercourse. It had to be small and lightweight with a separate battery pack, and in order for it not to interfere with other sexual activity, I wanted it to be held in place by straps so that neither partner would have to hold it.

I negotiated with a supplier of sexual novelties for what was later to be called the Butterfly, to be manufactured in Hong Kong. Although I had some significant critiques of the early prototype, by the time I saw it the manufacturer had already gone ahead with production. The Butterfly kept its inadequate design for close to ten years, during which time several other sex toy manufacturers copied it, and I did my best to dissociate myself from it.

My hope in inventing the Butterfly (sure wish I'd gotten a patent), was that look-ma-no-hands orgasms would soon be taken for granted, especially for the many hundreds of thousands of women who enjoy vaginal intercourse, but who can't come during intercourse without simultaneous clitoral stimulation.

I guess this was a pretty good idea, because although the original Butterfly disappeared from store shelves and catalogs some time ago, there have been a number of similar vibrators (strap-on clitoral stimulators) on the market ever since. Recently I saw that a hands-free butterfly-type vibrator is again being sold under the name Joni's Butterfly. (Since my name isn't spelled that way—it never has been—I can pretend that I had nothing to do with the Butterfly's design, except that you, dear readers, now know "the rest of the story.") Unfortunately, no way has yet been devised to hold the vibrator in exactly in the right place if the woman wearing one of these wants to move her legs or her pelvis while it's strapped on. Also, unless her hand or her partner's body is pressing the vibrator against her clitoris, it is difficult to get much direct stimulation from it.

If you want to try some no-hands style vibrators, there are a few that are worth a whirl. One model consists of a leather pouch, holding an egg-style vibe, with elastic bands to keep it in place. This toy has several advantages: Leather can be more comfortable next to the skin than plastic, and you can replace the vibrator if it breaks rather than having to buy a whole new toy. The four elastic bands attached to it fit over the top of the thigh and the hipbone, and provide a more secure fit than other models (and help keep the vibrator in place when you're wiggling around).

There are also several toys featuring very small (about an inch long) vibrating dolphins, butterflies, and other creatures attached to elastic straps. The vibrators on these models are surprisingly strong for their size. Although you might have to hold them in place with a finger or two, since they can move around a bit, their tiny size combined with relatively strong vibrations make them ideal for clitoral stimulation during partner sex. And, remember—these toys can be fun during solo sex, too.

Twice as nice

Vibrators designed for simultaneous clitoral and vaginal stimulation have legions of followers, but many women find that manipulating a dildo while holding on to a vibrator can be more work than pleasure. These vibrators feature a shaft that swivels, and a tiny vibrating animal-shaped prong that stimulates the clitoris at the same time. Most models have separate controls for the shaft and the critter, so that you can fine tune the rotation and vibration for maximum bliss. The rotation of the shaft can be great for hitting the G-spot, and these toys are fun for anal penetration, too. Some models also have beads or pearls encased in the shaft that tumble around as the shaft swivels. The movement of the pearls adds a little extra stimulation at the opening of the vagina but some say that doesn't increase pleasurable

Vibrator? or Dildo?

So what *is* the difference between a dildo and a vibrator? They're often confused. A battery- or electric-powered toy that vibrates is generally called a "vibrator," whether it is meant for insertion or external stimulation. "Dildos" are toys designed for either vaginal or anal insertion that don't vibrate. Dildos create a sensation of internal fullness and pressure that many find simply delightful. Some dildos also vibrate, hence the easy-to-remember term, "vibrating dildo."

When you're shopping for a toy, remember this: If you're looking for clitoral stimulation first and foremost, you probably want a vibrator. If it's penetration you crave, opt for a dildo. For the best of both worlds, choose a vibrating dildo—just remember to make sure the vibration is strong enough to get you off and the toy is the size you want for penetration—or buy a great vibrator and a great dildo and use them together.

sensation significantly.

The one caveat with these toys is that you have to make sure you get the right size. If you pick a model with a shaft that's too long for your body, the vibrating segment will completely miss your clitoris, instead vigorously vibrating the air about half an inch away. No fun. When in doubt, choose a model that's slightly shorter than you thought you wanted.

The last thing you need to know is that these toys are some of the most expensive battery-operated vibrators on the market. Although some fans think they are well worth the price, first-time vibrator users might want to experiment with less expensive models before investing in these top-of-the-line items.

Remote-controlled vibrators

Remote-controlled vibrators have been showing up in many people's fantasies for years. As the fantasy goes, she sashays into the company party (family holiday gathering, basketball game, local park) wearing a tightly fitting vibrator strapped on discreetly under her clothes. Her partner strolls in, remote control in pocket, and begins turning the vibrator on and off at

whim, teasing her or really turning her on and satisfying both their desires for public sex.

Unfortunately, at least to date, the few remote-controlled vibrators on the market haven't lived up to expectations. One model, an egg-shaped vibrator meant to be inserted vaginally, often overheats during use—and trust me, this is a particularly undesirable quality when someone else has control of the on-off switch! Toys meant to be worn over the clit are usually too big and bulky to be comfortable for any long period of time, and most operate only if the controller is less than twenty feet away from the wearer. Also, the remote-controlled vibrators designed as external strap-ons are all too loud to be used discreetly anywhere but in a noisy dance club.

Still, there's a good chance that in just a few years a workable remote-controlled vibrator will find its way to the market. The latest remote models are slim enough to fit under clothing, they are getting quieter and their overall quality is improving.

Waterproof vibrators

As fans of hot tubs and shower massagers will report, water and vibration do mix. And, finally, there are vibrators on the market that can go from the bedroom to the beach.

Initially, the main problem with creating a waterproof vibrator was designing one with a strong enough vibration. In order to protect the innards of the vibrator—batteries and wiring—from taking on water, the vibrator had to be well wrapped and insulated. So well insulated, in fact, that the vibrations that did make it through all those layers of protection were quite muffled. Some of these early models are still on the market, so you would do well to test out or inquire about the vibration strength before purchasing one.

That said, the newer models are ideal for water play. They come in a similar assortment of shapes and sizes as other battery vibrators: cylindrical or spherical, harder and softer materials. Their lifespan might be shorter than that of a regular battery vibrator, but

if you dry it off after use and treat it well, you'll have a toy that will no doubt add more interest to bath time than your rubber ducky.

Vibrating eggs

Some battery-powered vibrators are shaped like small eggs or rounded-off bullets. They are attached to a battery pack by a two-foot-long, thin plastic-coated wire. The earlier models were designed for internal vaginal stimulation and jokes are made about "wearing" them to the office to amuse oneself during boring staff meetings. This sort of vibrator is very unsafe for anal use. And it's good to remember that the little wire leading from bullet to battery pack isn't a pull cord, so bear down to push it out, grasping the slippery little devil with your fingers if you need to, while gently holding, not tugging on, the cord.

Some women find the sensation provided by vibrating eggs, "bullets" or spheres inserted into the vagina pleasurable, but usually only because the vibrations bring one's attention to the genital area, and help keep it there. Others find the sensation slightly annoying; a few may experience it as downright uncomfortable, closely akin to the feeling which accompanies a minor urinary tract infection. The fantasy that women will have powerful, multiple orgasms from this kind of stimulation is just that, a fantasy. However, this does not mean that the internal use of these devices will never result in orgasm, especially if they are used along with other kinds of pleasuring.

Twentieth-century technology has now brought us egg-shaped vibrators that run on microchips. Yes, those same gizmos that make your computer run faster are now making your vibrators smaller and stronger. Some of them measure a scant one inch long and three-eighths of an inch in diameter. This small size means the manufacturers recognize that vibrating eggs aren't just for penetration anymore, and you'll feel the difference in their

vibration strength. Instead of inserting them vaginally, use them on your clitoris. When they're this small, the vibration is very focused, so if you don't like ultra-direct stimulation, this kind of vibrator is not for you. But if you want a tiny toy to hold against your clit during penetration, a vibrating egg just might do the trick.

4

More Buzz for the Buck:
Buying a Vibrator

I F VIBRATORS ARE NEW to you, then talking with friends about them is helpful. Starting these conversations may be difficult for some people but the payoff, especially in terms of what you learn about yourself, should be substantial. If you have a friend who has a vibrator, borrow it and try it out before going shopping. Whether or not you like your friend's favorite toy, the conversation necessary to arrange the loan should be liberating and enlightening for both of you. If the vibrating surface of your borrowed toy is not easy to clean or wash before and after you use it, covering it with a condom or piece of plastic wrap will prevent the transmission of germs.

Stores

In some communities, department, discount, and drug stores may have a small selection of vibrators, two or three kinds or brands at the most. They are usually shelved with personal care products, such as hair dryers, or in the cosmetics or housewares departments.

Before you buy, ask to test the strength of the vibrations. Of course, you can't be sure from the sensation it produces on your hand or face how a certain vibrator will feel on your genitals, but you can check how strong it is, how heavy it is to hold, and you

can hear how it sounds. If you can't decide between a stronger and a weaker one, opt for the stronger; you can always use it through your clothing or a towel at first. Since different stores usually carry different brands, you may well want to look around before deciding.

If you're shopping for your vibrator at a department store, you might worry that the clerk will want to know what you plan to use it for. Horrors! But, chances are you'll never even get the hint of such a question. And if you do, you can always tell a little lie, perhaps muttering something about lower back pain or a pulled muscle, if this little deception will help you survive the ordeal.

The so-called "adult" bookstore presents a different atmosphere. The selection of vibrators is usually small, the prices are high, and the quality of the merchandise is generally poor. While women may be treated courteously in adult stores, more often they find that shopping there ranges from embarrassing and awkward to downright degrading. So, if you are a woman who wants to find out what's available at one of these places and you're not familiar with its reputation, send in a male friend first or go in with him or another woman.

Luckily, women-friendly sex toy stores are springing up all over the country. You may find that you need to drive only a few hours to find one. In these shops, you'll find a decidedly different attitude towards sex and sex toys. Expect friendly salespeople who encourage questions and are eager to give you information on different products. You'll probably find vibrators and other merchandise displayed without packages, so you can pick them up, turn them on and test the vibration strength. Unlike conventional "adult" stores, many of these shops offer exchange or return privileges, so you can bring back a vibrator that doesn't work.

Most importantly, these stores strive to create an environment where women are welcome. Many are owned by women or have women salespeople. Many also offer special classes or workshops that offer education on everything from striptease to female ejaculation. Although these stores are often geared towards women, they make shopping for sex toys pleasant for men, too. If there's not a women-friendly store within driving distance, by all means

see what you can find in the way of a catalog or website that reflects a similar approach!

Mail order catalogs

Starting in 1977 when Good Vibrations first opened, people from out of town came to visit with their San Francisco friends, then returned home only to call or write to order items they wished they'd bought while they were in the Bay Area. So we decided to create a catalog, which carries not only most of the vibrators described in this book, but also dildos, harnesses, massage oils, lubricants and lotions, ostrich feathers, books and videos.

If you want to order a vibrator from a catalog, there are more and more reputable companies that will ship quickly and reliably and will stand behind their products. Check the return policy of any company you're ordering from. A reliable company should accept returns of defective vibrators for at least thirty days—if they don't, you could be stuck with a brand-new sex toy that does little but look pretty. If you want to find out more about the company, ask how they choose toys, or how long the company has been around.

Finally, there's nothing wrong with asking a few questions about the toy you're about to buy. If you're unsure about exactly what that eight-headed vibrating toy is supposed to do, ask. As long as your questions are respectful and genuine, you should expect a friendly answer. There are plenty of friendly sex-toy companies out there that will be more than happy to help you select the right toy. So don't waste your time with one that won't.

On-line shopping

Surveys show that the number one use for the Internet is finding sex-related information and services and products. And no wonder—it's anonymous, fast and amazingly comprehensive. On the

one hand, it is truly wonderful that we can now review sexual products and talk over potential purchases with our spouses and lovers in the privacy of our own homes. On the other hand, the amount of information—and misinformation and hype—is so immense that it is very easy to get lost.

Until the advent of the Internet, most vibrator shoppers had to rely on a salesperson for advice on vibration strength, vibrator quality and specific uses. The explosion of chat rooms on the Internet—places where folks can talk, in relative anonymity, about whatever subject's on their mind—means you can actually get advice from someone who's not trying to make a sale. Granted, you can get some bad advice as well, but if you don't rely solely on one person's opinion (and why should you?), you can get a fairly objective picture of what a particular toy can actually do. Of course, you don't want to just drop in to any chat room and start asking questions about people's vibrator experiences; look for a chat room that is geared toward sexual health or information, take the temperature of the room and start out slowly with your questions.

Aside from privacy and anonymity, an obvious benefit of the Internet is the ease of comparison shopping. Instead of hoofing it all over town (if you happen to live in an area of the country where there's more than one sex toy shop in the first place), or making dozens of phone calls, you can drop by several different web sites and see what they have to offer. Be warned though: low price should not be your main objective when shopping for a vibrator. There are many poorly made vibrators that might not last for more than one use, that look virtually identical to their better made counterparts. And some pricey models might not last much longer. When comparison shopping, it's better to use your experience to get a feel for the reputability of the organization and the quality of their products than to find the best bargain.

Just like in the real world, not every cyber-shop is reputable or has your best interests at heart. Before you give up your credit card number, check a few things out. First, find out how the company deals with product returns. A reliable company should,

at the very least, accept returns of defective products for a period of time. Also, look for a site that provides some sex information along with its products. This is one indication that a company is genuinely interested in education as well as sales. Look for a toll-free number and mailing address on the web site so you have a way of contacting the company if their web address stops working. You might even try contacting them by phone or email with some questions to see how responsive they are. Finally, you should expect the same level of security for customer information that you would from any other web site. This means that they have secure on-line ordering and that they will not sell or give your name and other information to anyone else. And by all means, if you find a place on-line that's great, make sure you tell others about it, too!

Home parties

In the late 1970s, an East Coast woman started at-home parties to sell lingerie and a few sex toys to women whom she (correctly) believed would be embarrassed to shop in adult bookstores. Into the early eighties, these home pleasure parties flourished. At one time there were perhaps a thousand women running home parties independently or as sales reps for larger companies. This activity has decreased dramatically over the past few years, in part because it is now easier to buy sexy lingerie and other sensual products in regular stores and boutiques and by mail but probably more because the women running the parties found that they were not very lucrative.

Unfortunately, many of these party hostesses were not very well informed about human sexuality and were ill equipped to handle the questions and concerns that inevitably arise when a group of women starts talking openly about sex. More often than not, the manner in which the products were presented, and the information which accompanied them, reflected the attitude that sex is to be talked about only in a joking or sensational way. Also,

the presentations sometimes focused more on what would arouse the women's male partners than on what would give pleasure to the women themselves. Furthermore, the parties were usually directed to partnered, heterosexual women; and they did not appeal to many feminists, particularly if they happened to be lesbian or bisexual.

If you live in a suburban or urban area, with a little snooping around you may be able to find out who still is doing home parties, although there are many fewer to choose from than there were in the 1980s. Most party plans sell some books, lotions, oils and a relatively small selection of vibrators; some heavily promote lingerie. If you decide to seek out a vibrator at a home party instead of at a store or through the mail, ask in advance for a brief rundown of the products and presentation so you will know what to expect.

5

If It's Your First Time

I T FEELS GOOD TO PUT a vibrator on most parts of your body—shoulders, neck, lower back, thighs, rear end, face, hands, feet (if you're not too ticklish) and belly. But then, you didn't buy this book to find out about those uses. You want to know how to masturbate with the vibrator, and/or how to use one with a partner, right? Well, here goes.

> *"How had I reached the age 33 without ever trying a vibrator? Why isn't it more commonplace? Sex educators talk so much about masturbation—but I never heard of anyone suggesting vibrators for women.... I thought, every mother should tell her daughter about them; books on sexuality should explain their use."*
>
> —letter received from a Good Vibrations
> customer in the 1980s.

Doing what feels good

You can lie down, sit up, stand, kneel, squat, or do yoga postures while using your vibrator. Any way you hold your arms or legs is fine. You can move the vibrator, or yourself, or both, or neither. A woman can hold the vibrator directly on her clitoris, on or to the side of her clitoral hood, on her mons (the mound of flesh over the pubic bone), on the labia and around the anus or vaginal opening. Appropriately-shaped vibrators can be inserted

into the vagina or anus. Never put a vibrator (or for that matter, a finger or a penis) into your vagina after it has been in your (or anyone else's) anus. Wash it first, or put a condom over it. Bacteria natural to the intestinal tract can cause unpleasant infections in the vagina.

If you use your vibrator (or any other sex toy) for both vaginal and anal insertion and/or if you use it with more than one partner, it is a good idea to use a condom on it to prevent the spread of sexually transmitted diseases. Washing the toy with soap and water takes longer but is just as effective as using a condom, unless the toy has a porous surface or seams, nooks and crannies where stuff can get trapped.

You can stroke the genitals as fast or as slowly as you like, or simply press the vibrator lightly or firmly against one spot. You will probably find that as you become aroused your sensations will change. Some people want to speed up and/or increase pressure as they get more turned on; others feel the opposite desire, to slow down and/or lighten up.

Most women report two striking differences between vibrator-induced orgasms and those produced by other kinds of stimulation. First, the vibrator orgasm is reported to be more (or much more) intense. Second, it usually comes in a much shorter time, in some cases as little as sixty seconds or even less.

Some women who have never had more than one orgasm per session may find that with a vibrator they can have one or several more before going off to slumberland or getting up to go to work. Some women stay highly aroused between these two or more orgasms; others don't, but with continued stimulation find themselves getting turned on once again. Women who have previously had multiple orgasms may find that they can have even more per session when using a vibrator. Sometimes they use another masturbation method for the first few and a vibrator for the rest. Occasionally, the intensity of the first vibrator orgasm may cause a multi-orgasmic woman to feel like resting instead of continuing as she might otherwise do.

If you feel pretty sure that one is your limit, try this with your

vibrator. After your one regular orgasm and a rest of no more than ten to fifteen seconds, start moving or holding the vibrator near or on your most sensitive spot, continue to breathe deeply and easily, and see what happens. If at first you feel numb or a little oversensitive, keep breathing and moving your hips for a while, and chances are that your arousal will increase and you will have another or maybe several more orgasms. Of course, if the stimulation is actually painful, ease up on the pressure or move the vibrator to a different area of your genitals for a while.

The only real difference between using the vibrator and using your hand(s) to masturbate is that the vibrator moves faster and has more endurance. It won't change the ways and places you like to be stimulated.

Using a vibrator for anal/rectal stimulation

Battery-operated, dildo-type vibrators are often used for anal stimulation. Many men find that stimulating the anal opening, the lower rectum, and the prostate (through the wall of the rectum) with a vibrator is very pleasurable. Although women have no prostate, they are increasingly exploring anal stimulation both by themselves and with partners.

The anus is one of the most sensitive areas of the body, hence it has great potential for pleasure. Around the anus are many nerve endings that can be stimulated both by friction and also by muscular contractions. Many women and men enjoy the sensation of the anus contracting around something, such as a finger, vibrator or penis.

To become more comfortable with anal eroticism, start with gentle finger stimulation. Use plenty of lubricant because the anus has virtually no natural lubrication, and be sure fingernails are clipped very short and smooth, or wear a latex glove. If you are doing this with a partner and you are not absolutely confident that neither of you has or has been exposed to a sexually

transmitted disease, use a snugly fitting finger cot—like a condom for your finger—or wear a latex glove. After you feel very comfortable with the insertion of a finger, you may choose to experiment with more than one finger before trying the vibrator. It may take a number of sessions to get to the point where even one small finger can be there comfortably. Be sure and take your time.

Make sure you've selected a vibrator that is long enough for you or your partner to keep a good grip on. Sometimes people are tempted to use slim, smooth "mini" vibrators (less than five inches) for anal insertion. If you are using a straight vibrator (or dildo, for that matter), a significantly longer one is advisable, but if you must use a small vibrator, do not insert it more than inch or two into the anal opening and hold on tight to the other end with unlubed fingers.

First just touch and stroke the outside of the anus. Then when you feel ready, insert the vibrator. Move the vibrator in, and especially out, very slowly at first until you feel thoroughly familiar and comfortable with the sensation.

You can also experiment with a vibrator especially designed for anal/rectal stimulation. These are called vibrating plugs or butt plugs and are designed in such a way that once inserted they will

Give Yourself a Hand!

Statistics show more women use vibrators by themselves than with a partner. And, though most of us masturbate, buying a vibrator can feel like screaming at the top of your lungs, "Not only do I masturbate, but I want it better, longer and stronger!" In a society where sexuality can focus more on giving pleasure to a partner then giving pleasure to yourself, masturbation has developed an unsavory reputation as being selfish, dirty and practiced by those who aren't getting any "real" sex. And let's not even start talking about those crazy myths about hairy palms and going blind....

The fact is, masturbation is a great way to get in touch with your own sexual responses, rhythms and desires, and can be a part of anyone's sex life, whether or not he or she has a partner. Masturbation is a natural, healthy part of sexuality and a sexual practice worthy of recognition in its own right, whether or not you ever use a vibrator.

stay in place while the wearer engages in other activities, sexual or otherwise. They widen in the middle and taper near the base to keep them from slipping out. More important, they have a flange at the base to keep them from going in too far.

If you already have a silicone butt plug that doesn't vibrate, you can create a vibrating toy very easily with the help of a coil-operated vibe. Most coil-operated vibes come packaged with an attachment that resembles a suction cup. Stick the suction cup directly on the base of your silicone butt plug, turn on the coil-operated vibe and, voilà, a vibrating toy. And, since silicone products can be thoroughly cleaned by boiling them for a few minutes on the stove, you'll have one of the most hygienic butt toys around.

Also safe for anal use are the attachments for wand-type vibrators called the Wonder Wand (straight) and the G-Spotter (curved). They are well suited for this because the 4-inch insertable part is integrated with a vinyl cap that covers the entire head of the vibrator. We are told that the G-Spotter does a very creditable job of delivering vibrations to the prostate—certainly worth a try if you have a prostate and desire that kind of stimulation. In fact, the hook on many "G-spot" toys works very well at targeting the prostate, too—just make sure the toy you choose has a flared base.

For more guidance on this subject, get a copy of Jack Morin's *Anal Pleasure & Health: A Guide for Men and Women*, 3rd rev. ed. (Down There Press, 1998).

Care and feeding of your vibrator

The only thing that you need to feed your vibrator is a safe and consistent supply of electricity or fresh batteries, whichever it prefers.

Never immerse your line voltage vibrator in water, even when it is not plugged in. Simply wipe it clean with a damp cloth and soap. Plastic attachments can, of course, swim in soapy water.

Some people like to put a condom over the working end of the vibrator or attachment. Generally, however, this is unnecessary unless the vibrator is going to be used by more than one person in a single session.

The most common problem plug-in vibrators experience after some months or years of use is that they start to buzz intermittently and then quit working altogether. The cause of this demise is almost always a short in the cord right at the place where it enters the vibrator. If you can repair a lamp or toaster cord, or have a friend who can, you are in luck. Most plug-in vibrators can be taken apart so you can get at that part of the cord to splice it. There is usually no need to replace the cord altogether.

You can do three things to prevent short-in-the-cord wear and tear. First, don't wiggle your vibrator around too much when you are using it. Second, don't sit or lie on your vibrator with the cord bent and mashed under you. Finally, don't pick up your vibrator by the cord. (Well, okay, you can be forgiven if you have to do this once or twice a year in an emergency.)

As a coil vibrator ages, the attachments sometimes loosen, causing them to rattle. This ruins the coil's justly-praised silence, one of the characteristics for which you probably bought it in the first place. You can solve the problem by wrapping a small rubber band around the shaft of the vibrator and pushing the attachment down firmly until at least a bit of the rubber band is wedged between the metal shaft and the attachment.

Battery vibrators can produce quite a rattle if the batteries don't fit tightly in their housing. To combat this, try wrapping a few layers of paper around the batteries—the paper should take up the extra room and muffle the rattling sound. If you have a dead battery-operated vibrator which doesn't revive with new batteries, you can try bending any visible metal parts to ensure that the contacts are in fact making contact. Beyond that, the only future for it is a decent burial or a quick, terminal trip to the trash can. You can take it apart, but it is highly unlikely that you'll be able to put it back together again, because usually you have to break the plastic to get to the moving parts.

6

Women and Vibrators

MOST WOMEN WHO HAVE their first orgasm with a vibrator have never before had adequately intense stimulation. There is nothing abnormal about requiring intense stimulation to trigger an orgasm. Many people, for example, enjoy eating spicy food or turning up the volume on their stereos. Nobody really believes someone is weird for preferring these pleasurable sensations at above-average intensity.

Vibrators can be very important in optimizing women's newly discovered sexual responses. The popularity of vibrators has increased dramatically during recent years, and is still on the upswing, as more and more women learn more about the pleasure potential of masturbation and various forms of non-coital stimulation by partners. The search for the "look-ma-no-hands" coital orgasm is now driven more by curiosity than by desperation.

If you've never had an orgasm

First, make friends with your genitals. Look at them in the mirror and say hello with your fingers. Use some saliva or water-based lubricant for slipperiness. Find out which areas are especially sensitive to your touch and which are less so. Explore different kinds of touch, varying the speed and pressure. Don't expect to have an orgasm right away. It may take as long as several weeks

for your body to learn or relearn how to receive pleasure from your own touch.

Now, start touching yourself with your vibrator. If it has two "speeds" try them both. You may want to touch your belly, thighs, and hips first to see how it feels. When you first put the vibrator on your genitals, you may choose to use a towel or cloth between you and the vibrator. Or, you may want to hold the

Stand Up and Be Counted!

By the end of the '80s I was regularly asked what was known about vibrator use among women. So I approached Dr. Clive Davis, for many years editor of *The Journal of Sex Research* and Professor of Psychology at Syracuse University, and enlisted his assistance in designing some descriptive research to support (or not), the anecdotal information I was constantly hearing from customers, as well as from friends and acquaintances. Good Vibrations provided the study population, and Dr. Davis and his graduate students received the anonymous responses and analyzed the data.

The study, entitled "Characteristics of Vibrator Use Among Women," was published at the end of 1996 (*Journal of Sex Research*, Vol. 33, No. 4, 1996, pp. 313-320). The women who responded were 202 customers of Good Vibrations who had purchased a vibrator by mail in the months before the survey, and the sample was diverse geographically, in age and in sexual lifestyle. Readers who enjoy reading scholarly journals may wish to peruse the whole article. For the rest of you, an excerpt from the abstract should suffice:

"Vibrators were used primarily to enhance sexual responsiveness and sexual pleasure, most commonly in autoerotic activity, but for more than two thirds of the sample, also in partnered activity. [That might've surprised Dr. Davis, but not me!]. A majority indicated orgasms triggered by vibrator stimulation were more intense than others. [How startling!] Nearly half experienced multiple orgasms when using a vibrator. Most were very satisfied with their orgasmic experience in autoerotic activity, and were either moderately or very satisfied with their orgasmic experience in partner activity. [Another no-brainer, no?] The clitoris is the preferred site of vibrator stimulation for most, but there was great diversity in both preferred location and technique. These results were interpreted as indicating the value of being self-reliant in enhancing sexual responsiveness and satisfaction."

vibrator directly on your clitoris, on the hood covering the clitoris, or on the mons (the fatty mound covering your pubic bone.) If your vibrator is cylindrical (the battery-operated kind), or if it is an electric vibrator with a long (insertable) attachment, you can insert it into your vagina and/or move it gently in and out.

Although insertion may feel very good to you, it is improbable that you will become aroused enough to have an orgasm unless you stimulate the clitoral area at the same time with your fingers or another vibrator. Remember, there are few nerve endings inside the vagina that respond to light touch or friction. The entrance to the vagina and the inner lips may be very sensitive, however, and they can be reached comfortably with any vibrator.

If you are a male partner of a woman who has never had an orgasm, the fact that you are reading this book suggests that you are supportive of her using a vibrator to enhance her sexual pleasure. Please let her introduce you to her newly-found responses only when she feels ready to do so. If she is comfortable talking about it, encourage her to do so; if not, don't push her. The first few orgasms—even high levels of arousal without orgasm—can be very overwhelming to a woman who has never experienced them before. Also, recognize how unlikely it is that she will start having orgasms with intercourse right away.

It is possible that she will never become orgasmic with intercourse. However, if either of you thinks that there is only one "right" way to have an orgasm, please let me know what the "wrong" way is. I believe there is no such thing.

If you get aroused easily, but can't get over the top

Tease yourself. Stop and start again. Play with your arousal level. Stop "trying." This is supposed to be pleasurable, not hard work. Notice how much you can control your arousal level by changing the stimulation. Then see if you can become less aroused while

keeping the stimulation constant. Paradoxically, this often works by getting your mind off of trying to increase the arousal, and if practiced for a little while frequently triggers orgasm. If you enjoy sexual fantasies, let your mind go with whatever happens. If fantasy is not your thing, focus on the way all the parts of your body—not just your genitals—feel.

Remember, some degree of muscular tension goes along with sexual arousal. Focus on it and alternate exaggerating the tension and then relaxing. Move gently or vigorously, then hold very still. Play with your breath, too. Try slow, deep, regular breaths and then short, shallow, panting breaths. Then hold your breath for a few seconds and let it go with a big sigh.

Spend a little time every day masturbating with your vibrator and hands without the expectation of having an orgasm. It may take twenty to thirty minutes or more at first, and the first few orgasms may take you by surprise. They may be very mild, even disappointing, or very intense. Give yourself time to figure out exactly what unique combination of conditions suits you best.

> "When a woman is new to vibrator sex, she may experience any number of responses. One friend reported that the first time she used her vibrator, she had the most intense orgasm of her life, but it was over before she knew what had happened. Another said her orgasm was ever so slight, lasting only a second. And yet another woman had to practice patiently for several months before anything sexual happened."
>
> – Betty Dodson in *Sex for One*

Vaginal vibration and the G-spot

For the past twenty years, women have been rejoicing in the discovery that clitoral stimulation can give them great pleasure and assure them plentiful and reliable orgasms.

During the earlier part of this period, the word was that if a woman was orgasmic with vaginal stimulation alone (usually

Give Yourself a Squeeze—PC Exercises

You'll often hear mainstream advice columnists touting PC exercises (sometimes called "Kegels" after the doctor who popularized them) as the cure-all for urinary incontinence, but rarely do they mention the glorious effect that PC exercises can have on your sex life. PC is short for the pubococcygeous muscles, a sling of pelvic muscles that surrounds the anus, a woman's clitoris and vagina, and the base of a man's penis. These are the muscles that contract rhythmically during orgasm, and both men and women can increase orgasmic response by toning them.

The technique for locating and exercising the PC muscles is the same for men and women. While urinating, try and stop the flow in midstream. The muscles you use to do this are the same muscles you want to target with your PC exercises. Once you know where the muscles are, begin rhythmically squeezing and relaxing them, holding each movement for about a second. Start with two sets of 10, then work your way up to longer repetitions. As you become more comfortable, try alternating the amount of time you hold and release each squeeze—sometimes holding it longer, sometimes doing a quicker, "flutter" motion. Some people do as many as 100 squeezes at a time, and we can tell you, they're much more fun than sit-ups.

If you're already orgasmic, doing PC squeezes can make your orgasms even stronger. If you're pre-orgasmic, you might find that doing PC exercises will help you orgasm. Many men and women find these exercises allow them greater control over the timing of their orgasms; some men even report that these exercises helped them discover their ability to have multiple orgasms.

And, the exercises are easy to practice with a vibrator. While you're using the vibrator (probably on your clitoris) and as your excitement starts to increase, begin rhythmically contracting and releasing your PC muscles. For some people, simply contracting the muscles during sexual excitement can trigger an orgasm. Once you've started to orgasm, continue contracting and releasing the muscles, breathe deeply and slowly, and see if you can extend the length or intensity of your climax. If you insert a finger or two into the opening of the vagina while you are doing this, you may notice that the muscles contract intermittently and randomly as you become aroused. There are 8-12 contractions in most orgasms, but they diminish in intensity quite rapidly, which is why you might perceive only the very first ones.

Even if you notice little change in your arousal from your PC exercises, keep on practicing. You have nothing to lose by keeping these muscles toned, and the stronger your muscles, the greater your capacity for pleasure.

meaning intercourse), the real orgasm trigger was indirect clitoral stimulation incidental to penile thrusting. Since it is impossible to stimulate the vagina during intercourse without stimulating the clitoral area at least indirectly at the same time, you can see how difficult it has been to sort this out. Nevertheless, the acknowledgment of clitoral orgasms has helped thousands of women who felt themselves to be deficient in their sexual response to feel "normal" again. Many heterosexual women report that they now feel far less dependent on their partners. In addition, more people can now understand how two women can be sexual together without using a penis substitute.

Unfortunately—and frankly because we didn't know any better at the time—the experiences of certain women were discounted or disbelieved in the enthusiastic rush to accept new explanations and the "scientific" evidence supporting them. I am referring to those women who have consistently claimed that the orgasms they have during intercourse are significantly different in several ways from those resulting from direct clitoral stimulation.

Also discounted have been the experiences of women who claim they are orgasmic only during intercourse and who may even actively dislike direct clitoral stimulation. Finally, for years no one believed women who claim that they ejaculate or experience an involuntary expulsion of fluid during coital orgasm or other vaginal or clitoral stimulation. They have been told that they are either lying or suffering from urinary stress incontinence, that is, losing urine at the moment of orgasm because of weakness of the musculature around the urethra.

However, contemporary research about female sexual response will in all probability turn our ideas upside down. This research suggests:

- that women have a small body of prostate-like tissue surrounding the urethra,

- that many women find stimulation of this area (called the Graefenberg spot, or G-spot) through the anterior (top or front) wall of the vagina by fingers, dildo, or penis to be very pleasurable and arousing, and

- that some women who experience orgasm from this stimulation ejaculate a fluid through the urethra during these orgasms.

The fluid expelled closely resembles male seminal fluid (semen without sperm) in its chemical composition. It may be that many women who at one time experienced such ejaculation have learned to hold back the ejaculate so that it backs up into the bladder. (This phenomenon is called retrograde ejaculation; it is common in men who have had certain types of prostate surgery.) This attempt to hold back the embarrassing ejaculation may inhibit orgasm altogether, so that these women are no longer orgasmic with vaginal stimulation.

Since a good part of the vibrator explosion is associated with the celebration of clitoral sexuality, vibrators should naturally be a part of any future breakthroughs. Those of us who are vibrator enthusiasts will want to find out how we can use vibrators for stimulation of the G-spot and by so doing expand our capacity for arousal and orgasm. It is almost impossible for a woman to give herself effective G-spot stimulation using her own finger(s). It can be done if she uses an object such as a straight vibrator in her vagina, but she may find it awkward.

There are now quite a few "G-spot vibrators" on the market that make it easier to target the G-spot, including battery vibrators and attachments for plug-in vibrators. You'll recognize them by the distinctive curve, or hook, at the business end of the toy which focuses sensation right on the G-spot.

Most women like strong, firm pressure on the G-spot, so you might want to make sure that your toy won't bend too easily during use. The failure of most battery vibrators marketed for G-spot stimulation is that they are simply too flimsy to apply any real pressure. And remember that the G-spot is usually located only two to three inches into the vagina, so you won't necessarily need a long toy to find it. The reports are somewhat mixed in terms of how women respond to G-spot vibration—some women love it, some find that they only notice deeper stimulation, not the surface sensation of vibration.

Depending on the shape of your vibrator, you can try pressing or rubbing the G-spot through the vaginal wall, or from the outside, by pressing the vibrator firmly downward on the lower abdomen right at the pubic hair line. Some women find this sensation irritating if they are insufficiently aroused. Stop if any of your experiments result in prolonged feelings of urinary urgency or any pain. This is not a contest in sexual versatility. You are seeking pleasure, and the search should not be unpleasant.

For extensive information on finding and stimulating the G-spot, check out *The Good Vibrations Guide: The G-Spot*, by Cathy Winks (Down There Press, 1998).

7

Men and Vibrators

I T IS A POPULAR BELIEF that vibrators are used almost exclusively by women. Theoretically, this doesn't make sense. If men, like women, enjoy a wide range of stimuli (and we know that they do), then why shouldn't a vibrator be another potential source of sexually arousing stimulation? The problem with this theory is that it fails to take into account social inhibitors and the attitudes that many men have about vibrators. Some of these negative ideas men and women share: vibrators are too mechanical; they may be habit-forming; masturbation does not have a lot of value anyway.

Other beliefs seem to belong almost exclusively to men. One of these is the fear of appearing feminine either to oneself or to others. Vibrators have for so long been thought of as sex toys for women that some men react defensively to the suggestion they might enjoy using the vibrator for themselves. Some men, when asked if they have ever used a vibrator, will happily describe the times they've used a vibrator "on" or with a woman, but would never admit having considered using it for self-stimulation or inviting a partner to stimulate them with it.

Some heterosexual men believe that only homosexual men use vibrators, and then only for anal stimulation. That means a few may even believe that if they use a vibrator they are or will become homosexual. Some men are negative about masturbation in any form. Of course, some women feel this way as well. However, men usually start masturbation earlier in life and

usually experience more overt negativity about it from parents and other adults. Therefore, they are somewhat more likely than women to view adult masturbation as a bad habit. Whatever the reasons, it seems that a majority of women who feel very negative about masturbation simply don't do it. By contrast, it seems most men do masturbate, whether or not they feel good about it. And the man who feels that masturbation is a bad habit is not likely to seek out anything to enhance that experience.

Virtually all men who masturbate are orgasmic. Therefore, many men have difficulty understanding how a woman cannot always come when masturbating manually. Since men's usual way of masturbation is 100% reliable, they will often say, "I don't need a vibrator." These men don't think of the vibrator as an enhancer or alternative; they think of it as a crutch for a woman who cannot have an orgasm without it. Moreover, the dildo vibrators that most men know of or visualize when they think of vibrators seem designed to stimulate a woman's vagina, not the male genitals.

Some men have tried a vibrator for self-stimulation but do not continue to use it after one or a few brief attempts. Of these, some are probably men who do not masturbate with any regularity for a variety of reasons. I have talked with others who, though eager to try self-stimulation with a vibrator, have been disappointed when it didn't "do anything" for them. Here are some common reactions:

+ "It was too fast and it just didn't feel good at all."
+ "It felt good but I didn't get an erection or get aroused."
+ "I felt turned on and I got an erection but I couldn't come; I had to turn off the vibrator and go back to my usual method when I wanted to come."
+ "After I got an erection it started to feel boring and sort of numb, so I quit."
+ "I eventually ejaculated but it took me so long and seemed like such hard work that I probably won't do it again."

Some of these responses reflect the goal orientation so prevalent in the sexual attitudes of most of us. We tend to reject that

which only feels good in favor of that which arouses us or gives us orgasms. We forget that unless we learn about, acknowledge and focus on that which feels good, sexual experience is reduced to a mechanical exercise or an athletic performance.

> *"Picking up an electric vibrator, I put it in his hands, turned on the switch, and guided it over his limp penis until I saw a faint smile on his lips. Later, Al [reported] how amazed he was to have had a second orgasm with a vibrator and a soft-on."*

> – Betty Dodson, in *Sex for One*

If you are a man and have not had an experience with a vibrator or have been disappointed when you experimented before, and if you want to check out the pleasure potential of the vibrator further, you can follow some of the suggestions for use given earlier for women. In addition, consider the following:

* Some men do not get erections at all or get only partial erections when they stimulate themselves with a vibrator. Nevertheless, according to some individual reports, this in no way affects the sense of arousal. In other words, you may feel just as turned on as you typically would with a full erection.

* It sometimes takes a long time for a man to come with a vibrator. Some men have several orgasms during this relatively long arousal period before ejaculating.

* If you are not using a device that surrounds the penis, you may want to cup your hand around your penis so that the vibrator touches your hand, making a ring of sensation rather than a spot. Another way to spread the sensation is to press your penis against your abdomen with the vibrator.

* If the vibration doesn't feel good directly on the penis, experiment with holding the vibrator or stroking with it at the base of the penis, on the scrotum, on the perineum, around the anal opening or against the pubic bone.

* If you want to stimulate the prostate through the wall of the

rectum, remember to use a butt plug, or a battery-operated dildo vibrator which is long enough so that you (or your partner) won't lose hold of it. Some men have experienced ejaculation from prostate stimulation in a doctor's office, but do not describe it as particularly pleasurable. In a more sensual setting, and perhaps with the aid of fantasy, anal/prostate stimulation can trigger orgasm as well as ejaculation. G-Spotter attachments for wand vibrators are also great for this.

• If you choose to try anal stimulation with a vibrator, you can, of course, combine it either with your usual form of masturbation or stimulation of your genitals by a partner.

In recent years several books have been written and techniques promoted to teach men how to be multiply orgasmic, usually without ejaculation. One teacher of these techniques recommends using a vibrator. The others do not specifically recommend vibrators, but also do not specifically discourage vibrator use.

It is not known how vibrator use actually affects orgasmic capacity. Nor do we know how men who use vibrators might describe their arousal and orgasm in contrast to that generated by other forms of stimulation.

Toys exclusively for men

In addition to traditional plug-in and battery vibrators, which can be used to stimulate the anal opening, the prostate and the genitals, you may decide to experiment with some of the toys designed exclusively for men. Many combine vibrations with other sensations you might find equally as pleasant.

One option mentioned earlier is the Come Cup-type of vibrator attachment. This tulip-like attachment, for coil-operated or some battery vibrators, directly vibrates the head of the penis. Since only the glans is stimulated by the Come Cup, some men complain that the shaft of their penis lacks attention when they use it. For this reason, many men supplement the focused vibra-

tions with some hand strokes of their own.

You could also try a vibrating sleeve. These long, slender tubes house a vibrator and encase the entire penis; some are also lined with little nubbies for extra sensation. For easiest use, simply slide the entire tube up and down the shaft of the penis. The drawback of this type of toy comes during cleanup. If the vibrator is encased in the sleeve, as many are, you cannot submerge the toy in water to clean it, and the tube-like shape makes some spots hard to reach. If this is of concern to you, try wearing a condom when you use the toy, or make sure you select a model that offers a removable vibrator for easier cleanup.

Vibrating pumps are a fascinating, but sometimes unwieldy, option. A hard plastic tube is placed over the penis (and, often, the scrotum), and a vacuum-like system, usually controlled by a hand pump, draws air out of the tube. This creates a suction on the penis that can be extremely pleasurable for some (with a feeling akin to a blow job) and a bit frightening for others. Choose one that has a vibrator as part of the setup and you're in for quite a ride.

Some men swear by vibrating cock rings. Cock rings are meant to fit around the base of the penis, circling around the shaft of the penis and the scrotal sac, or balls. They restrict blood flow from the penis, creating pressure and a sense of fullness. Vibrating cock rings have a small bullet-type vibrator attached. Not only does this provide a pleasant buzz for the penis, but you can change the position of the vibrator, placing it directly against your scrotum or positioning it so it also delivers pleasurable vibrations to a partner with whom you are practicing insertive sex.

8

Just the Three of Us:
Vibrators and Partner Play

*"Whenever I came home, there was my new electric vibrator,
waiting faithfully to give me endless hours of pleasure....
What saved me from going steady was careful consideration of
her shortcomings: all buzz and no conversation, and she never
initiated lovemaking."*

—Betty Dodson in *Sex for One*

SOME OF YOU MAY BE fortunate enough to have dis-
covered the joys of vibrators with the full knowledge and
enthusiastic involvement of one or more sexual partners.
However, if the vibrator is new to your partner, or if he or she
has expressed negative feelings about vibrator use, you may be
reluctant to introduce it into your sex life with this person. It is
your responsibility to present your interest in using the vibrator
in such a way that it will be well-received. You might be surprised
at how supportive your partner is, especially if you initiate the
discussion with the intent of sharing your enthusiasm.

Some heterosexual men are resistant to learning about clitoral
stimulation in particular. If your partner is one of those men for
whom "real sex" begins and ends with penis/vagina intercourse,
you may have to go through an educational process to help him
understand your reality.

If you are a heterosexual woman who is not orgasmic with

penis/vagina intercourse alone (like forty to seventy percent of all women), you may start having orgasms during intercourse as you become more comfortable with stroking your clitoris at the same time. After becoming reliably orgasmic this way, some women want to try taking the hand or vibrator away from the clitoris before they come to see if intercourse alone will take them over the top. Others, delighted with the orgasm just the way it is, don't want to risk missing it even once, just for the sake of experiment. As long as a look-ma-no-hands orgasm is your goal, and not your partner's (or someone else's) goal for you, pursue it if you like. If you enjoy the vibrator regularly, you may plan occasional or even frequent partnered sex during which you don't use your vibrator. Keeping it handy anyway is very reassuring. It's nice to know that you can pop an extra orgasm or two into the encounter or that you can revive your sexual interest if it flags before you and your partner are ready to call it a night.

Contrary to popular belief, you do not have to be a human pretzel to give yourself clitoral stimulation with or without the vibrator while having intercourse. The missionary position—man on top, woman on the bottom—is probably not the best position for clitoral stimulation, unless your partner wants to position his body at more or less of a right angle to yours instead of parallel to it, so you can reach your clitoris. In alternative related positions the man kneels between the woman's thighs or stands while she lies on her back on a high bed or a table. Most

rear entry positions are good except ones in which you are flat on your stomach. Woman astride or on top is excellent if you are comfortable in it. A favorite for many couples has the woman on her back, the man on his side, close to and facing her, with both her legs draped over his thighs. In a slight variation, the legs are intertwined in a way that defies description. There

are many other options. Your own explorations should be much more fun than reading this paragraph.

Who should hold the vibrator? It is often hard for even the most diligent lover to stay in touch with a woman's clitoris with his or her hand or mouth. Unless you like the vibrator held still while you move against it, it's best to hold it yourself.

If you are a man introducing a vibrator to a reluctant female partner, try to understand her resistance, particularly if you learned about vibrators from a previous woman partner who may have been more sexually sophisticated than your current partner. When purchasing a vibrator for such a woman, you would do well to choose one that feels good to you, at least for massage. Then you can bring it to bed as a toy for both of you to enjoy. If you scoff at the idea of enjoying the vibrator yourself, you run the risk of making her feel deficient in some way, as if she needs mechanical assistance while you do not.

If you are a woman who enjoys a vibrator a great deal when masturbating and who wants to "come out of the closet" about your vibrator use, here are some things you can do:

◆ Have a talk with a friend (not a sexual partner and preferably someone of the same sex) about masturbation and vibrators. Allow yourself to be as explicit as you can in order to learn as much as possible about yourself. Verbally explore not only your attitudes and those of your friend, but also your behavior. If he or she has tried a vibrator or uses one regularly, inquire about and share your experiences with specific techniques. If neither of you has any experience with partnered vibration, brainstorm about what might feel good. If you expect to get a negative reaction when introducing the vibrator, do some worst-case thinking about what your partner might say and role play your assertive response.

◆ Do the same thing with your lover or spouse. The experience will probably be substantially different. Resist having this conversation in the middle of a sexual encounter—it can complicate both the discussion and the sex. Remember that if your partner is

critical of you, he or she is really telling you something about him/herself. If you do get criticism, try to hear, acknowledge and then talk about the feeling(s) lurking behind it. View this as an experiment and remind yourself and your partner that the worst that can happen is that the discussion won't be all that much fun—in which case you probably won't do it again. Most of the time, anticipated negative reactions to vibrators never materialize. Chances are you'll wish you hadn't waited and worried as long as you did.

+ Make a date for a vibrator playtime with a cooperative partner. Choose someone who will let you proceed at your own pace. Plan some sexual activities for the session that don't involve the vibrator (perhaps some you've enjoyed together before) so that if the vibrator doesn't make both of you feel good, the session will be fun anyway. Take lots of breaks. If you have a vibrator that is good for all-over-body massage, take this opportunity to allow your partner to pleasure you non-sexually with it for part or all of one or several sessions. After the playtime is over, have a talk about how it was for each of you.

+ Get your vibrator out of the bottom drawer and put it out in the open by your bed. Start thinking of it as a useful household appliance and keep it handy.

+ Consider adding a new kind of vibrator to your collection and go shopping for the new toy with your partner. Or, select one from a mail order catalog or web site together.

Adding a vibrator to harness play

Many couples, of all orientations, are discovering that using dildos and harnesses (also called "strap-ons") can really expand their sexual repertoire and fantasy play. Harnesses and dildos can be used for vaginal or anal insertion. Straight and gay couples, who in the past might have thought that harnesses were made exclusively for lesbians, have found that their appetite for dif-

ferent sizes and shapes of insertable
objects, and the duration of "inter-
course," can be satisfied by adding
dildos and harnesses to their sex play.
But, again and again, folks want to
know how they can incorporate that
delicious feeling of vibration into
their harness play.

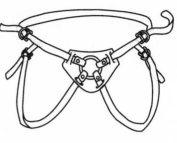

Vibration during harness play presents many of the same chal-
lenges as vibration during penis-vagina intercourse: it's difficult
for both partners to receive adequate stimulation and it's particu-
larly hard for women interested in steady clitoral stimulation (as
so many of us are!) to find the right tool for the job.

Harnesses present an additional challenge. Whether they're
made of fabric or leather, harnesses are supposed to fit the wearer
snugly, and placing a toy between the harness and your skin can
be awkward at best, even uncomfortable. Nonetheless, there are
many toys available that can enhance your harness play.

Those on the receiving end have much the same options as
during any partner sex. Women can hold a battery-operated
or electric vibrator against the clitoris, or strap on one of the
no-hands "butterfly" types. Men can also hold a vibrator against
the sensitive parts of their penis while being penetrated, or may
wish to use one of the vibrating sleeves mentioned in the earlier
section about toys for men.

The person wearing the harness might try slipping a tiny,
vibrating egg between the harness and his or her body. Some of
the newer egg-type vibes are a mere one inch long and just three-
eighths of an inch in diameter, making them barely noticeable
(except for the strong vibrations). And you don't have to have a
penis to enjoy a vibrating cock ring—slip one on your dildo and,
presto, instant vibration for both of you.

Additionally, there are now vibrating dildos on the market that
are well-suited for harness play and provide stimulation for both
partners. The harness wearer can position the dildo so the vibrat-
ing base is positioned right up against the clitoris or shaft of the

penis. While a woman being penetrated vaginally still won't get constant clitoral stimulation, she will get some extra sensation. And vibrating dildos are great for anal insertion, since vibration can help relax the anal muscles.

When shopping for a vibrating dildo, make sure the toy you choose has a wide enough base (usually at least ½″ wider than the base of the toy) that it won't pull out of your harness.

Many vibrating dildos that are harness-compatible are made of soft, translucent jelly rubber with a vibrating egg inside. You can also find some made of silicone. Silicone transmits vibrations better than jelly rubber, and it also warms to body temperature when you use it, so this kind is well worth the extra cost. If you can find one that features a removable vibrating egg, by all means get it. The vibrating mechanism probably has a shorter lifespan than the dildo itself, so with a removable egg, you only have to replace the vibrator.

9

But What About...?
Questions, Concerns and Tips

Water and vibrators

Common sense dictates against using a plug-in vibrator (or any electrical appliance) in the bathtub, shower, swimming pool, hot tub or other watery venues. However, these are good places to experiment with getting turned on by a fast-running stream of water. The faucet in your tub, a bidet, the inlet of a swimming pool or jacuzzi, a hand-held shower massager or a water pick (designed for cleaning teeth) are all worth a try. Of course, you can always try a battery vibrator designed exclusively for use in the water, as mentioned in the battery vibrator chapter.

Be very careful with the water pick or shower massager. They push water out at a pretty high velocity, which can be painful. And never direct a stream of water under pressure into your vagina. It is possible to force water and air bubbles through the cervix into the uterine cavity, where they can cause no end of very serious trouble.

A woman who lubricates copiously, urinates a little, or ejaculates when she becomes highly aroused or has an orgasm, might be concerned about getting a shock, shorting out or rusting her electric vibrator. I've never heard of this happening, but if it makes you feel more relaxed, hold the body or motor of the vibrator off to the side or up toward your belly button so it won't get wet.

Vibrators—who's the boss?

Some people worry that they will become addicted to the vibrator. If an addiction is a habit that is in some way harmful to a person, then the words "vibrator" and "addiction" don't even belong in the same sentence. Some women do get so accustomed to vibrator stimulation that for a time they may enjoy it more than any other stimulation. But those who have had orgasms in other ways usually continue to do so with no difficulty. A few people eventually give up other kinds of sex play with themselves and with partners and head straight for the machine. If this describes you and you want to get unhooked, this is what you can do.

Give yourself some extended time alone and/or with a partner to enjoy non-vibrator sexual activities. If you find yourself trying to have an orgasm, slow down the stimulation, or stop and start again. Pay attention to what feels good and what feels better, and you will start to feel aroused again. If you are with a partner who is stimulating you, ask him or her to slow down, move over or stop when you observe yourself trying to come. Do not expect any orgasm you happen to have with manual, oral or coital stimulation to feel the same as those you have become accustomed to with the vibrator.

Chances are these orgasms will be somewhat less intense at first. After a while, if you don't use the vibrator at all, your responses will be back to what they were before you started with the vibrator.

Of course, if you have become orgasmic since using a vibrator, you will maintain that status. Rejoice, you are now orgasmic, and you got there by yourself. Celebrate your new independence, and don't let a sexual partner or anyone else convince you that your reliance on your vibrator is the least bit unhealthy.

A few women have rarely or never experienced any pleasure they could label sexual until they discovered the vibrator. You may think that such a woman is more likely than others to get "stuck" on her vibrator. Not so. Generally, vibrator use gives this woman confidence and the knowledge that her body is responsive, and she can go on to discover new ways of turning herself on.

*"There are some myths and concerns circulating about vibra-
tors which probably prevent some women from trying them
out. The most common myth is that a vibrator provides sensa-
tions which are so marvelous and sinfully gratifying that it
will replace your partner or make it impossible for you to
come using anything but a vibrator. This is a half-truth...we
don't worry about someone getting addicted to oral sex."*

– Pat Califia in *Sapphistry*

Some sex therapists recommend weaning oneself from the vibrator,
but I am not one of them. Some women have done this success-
fully, others have tried and failed. Since I am not a believer in wean-
ing, I am not a good source of information on how to go about
attempting it. To me, it implies that the best way to reach orgasm is
the "natural" way, that the vibrator is a crutch you shouldn't need
when you grow up, and/or that it's not a good habit.

Some people feel that if they enjoy masturbation with the
vibrator, they might masturbate too much. Since the 1940s we've
been reading that masturbation is all right as long as a person
(in the books it was usually a male adolescent person) doesn't
do it "to excess." For years I turned eagerly to the chapter on
masturbation in each new book on sex, hoping it would tell me
how much was excessive. It never did! You will know it's too much
for you if you often find yourself masturbating when you would
rather be doing something else.

An alternative to getting unhooked is to decide that you feel
okay about being a vibrator enthusiast and then buzz off as much
as you want. Unlike some addictions, this habit has no known
detrimental physical side effects. In any event, just as one cannot
blame food for compulsive overeating, one cannot blame a vibra-
tor for compulsive masturbation— if indeed such a thing even
exists.

Sex researchers and counselors working with women are find-
ing that the more times a woman experiences sexual response, the
more reliable her response becomes. In fact, I believe that if girls

discovered their clitorises in infancy and masturbated throughout their lives, as most boys and men do, they would experience fewer difficulties with sexual response as adults.

I would urge both men and women to let go of the demands they place on themselves about having an orgasm or having a certain number of orgasms each time they become aroused (alone or together).

If you're not worried about vibrator addiction, but your partner is, invite him or her to read this book, especially this section, and then talk over his or her concerns. Then, see if your partner is actually worried that you will start to enjoy solo sex more than sex with him or her. If so, invite your partner to be with you during a masturbation session or start practicing the activities suggested just a few pages ahead.

Even sex therapists who routinely prescribe masturbation as therapy for orgasm concerns often do not see self-pleasuring as a worthy end in itself. So it's not surprising that partners who have some uneasiness about their own masturbation may be less than enthusiastic about yours.

Remember that no modern society, even late twentieth-century American society, has bestowed any value whatsoever on masturbation.

But my therapist said...

Over the years, hundreds of women have purchased vibrators on the specific recommendation of their therapists. However, one Good Vibrations customer wrote to tell us that her therapist had instructed her to throw away her vibrator. She and her husband were going to the therapist because her husband had difficulty maintaining an erection. My guess is that the therapist was concerned that this woman would masturbate during the course of the therapy and then find it harder to become aroused during intercourse once her husband's difficulties were resolved.

It is very common in couples sex therapy for the therapist to

prescribe a short-term ban on intercourse or on whatever sexual activity seems to be causing the most anxiety. It is rare, however, that a sex therapist will ask couples to abstain from all sexual activity, including masturbation (as this therapist did). As a matter of fact, masturbation practice is often recommended as a way for both partners to learn more about their own sexual response.

Unfortunately, some therapists who support masturbation are not equally enthusiastic about vibrator use. Fortunately, for every therapist who thinks vibrators are habit-forming, dozens of others see them as pleasure-enhancing and consequently therapeutic.

You're in control

Although your vibrator moves fast, it doesn't have a mind of its own. The hand that holds it is always in control. If you doubt that, experiment by moving your vibrator onto and away from your most sensitive area, starting and stopping, or teasing yourself. Alternate the vibrator with your fingers, moving it at different speeds, and with varying amounts of pressure. A good basic rule of thumb is: if it doesn't hurt, it won't hurt you...and it might feel wonderful. In this regard, remember that when a person is highly aroused his or her pain tolerance goes way up. You will want to exercise caution at first if you choose to exert a lot of pressure or rub your vibrator vigorously on your skin or mucous membranes.

Can the vibrator numb your genitals or damage nerve endings in some way? Not that we know of. Your clitoris or penis may indeed feel numb after you have held the vibrator on it for some minutes. Slowing down, moving the vibrator over slightly, or stopping for a few minutes and starting again, will almost always bring back pleasurable sensations.

People who like playing with the vibrator for long periods of time may experience a range of sensations including numbness and oversensitivity, as well as warmth, tingling or throbbing. The genitals are not like the ear. Although loud music or noise can

cause permanent hearing loss, lots of genital stimulation, even intense stimulation, does not result in loss of sexual excitability. Au contraire, it seems as if the more you use it the better it works!

"If you get off on using your electric massager and start feeling guilty about it, ask yourself why you're afraid of feeling good."

– Pat Califia in *Sapphistry*

Vibrators and disability

People with physical disabilities often find that adding a vibrator to sex play can open up new opportunities for pleasure. Sexual independence is a right that belongs to all of us, whatever our degree of physical ability.

Adults with certain physical disabilities have discovered vibrators to be a real boon to their sexual explorations. People with limited genital sensation sometimes find that a strong vibrator can "get through" to them when hand stimulation cannot. This may be especially important for diabetics who are experiencing some neuropathy (nerve damage). You might want to try the stronger vibrations offered by an electric vibrator, or battery vibrators made out of harder materials like plastic, as they transmit vibration better. More focused vibrations can sometimes feel stronger as well, so try using a vibrator with a smaller surface area. The spot attachments on the coil-operated vibrators, or smaller egg-type vibrators, are a good bet for focused vibration.

Many people whose hands and arms tire easily or those who have limited strength or mobility in their arms and hands find the vibrator very useful in helping them become sexually independent. A vibrator can provide consistent stimulation that hands or arms can't. If you have trouble holding a vibrator for a long time, try strapping on one of the hands-free models mentioned earlier. These models fit directly over the genitals, so you can simply lie back and enjoy.

Some vibrator models are angled or have a longer handle, making it easier to provide leverage and firm pressure. Unfortunately, most of the vibrators that deliver the strongest vibrations are also the heaviest, which is problematic if one has both diminished genital sensation and limited strength and mobility. One harness manufacturer used to make a harness which allowed a woman to place and hold an electric vibrator directly over the clitoris; it's no longer on the market, but a woman can try tucking the head of a wand-style vibrator into a pair of tight-fitting briefs or panties. Some people find that lying on top of an electric vibrator allows for hands-free pressure, but the handle of the vibrator can become dangerously hot if it is "smothered" by the user's body, so caution is in order.

Speech therapists have used small battery-operated vibrators to help their patients develop awareness and improve function of the small muscles around the mouth. And therapists and teachers who work with deaf and blind children have reported that vibrators can provide a new range of sensation for kids whose interaction with their environment is significantly impaired by their disability.

Please be aware that both electric and battery vibrators will heat up with use, some in 15 minutes or even less. So those with decreased sensation or mobility should be particularly careful to monitor the heat of their toy, and check frequently for reddening of the skin during use.

Health considerations and special uses

Vibrators and massagers sold in the United States have for years been labeled as follows: "Do not use on swollen areas or on unexplained calf pain." The latter part of this warning relates to the risk of shaking loose a blood clot (embolus) which could travel to the lung or the brain, potentially causing serious damage or even death.

You also will see some battery-operated vibrators labeled "sold as a novelty only." The manufacturer wants to be sure you

know that he or she is making no therapeutic claims for his product, because if he does, it becomes subject to Food and Drug Administration (FDA) regulation. When the FDA was drawing up regulations in the late 1970s, it received comments suggesting that it should not waste Federal tax money to regulate genital vibrators. I agree, and apparently so does the FDA, because they are concerned only with genital vibrators "intended and labeled for therapeutic use."

Occasionally a physician or physical therapist will recommend the non-sexual use of a vibrator for a medical problem. If you have a painful or otherwise uncomfortable condition that you think would be relieved by vibration or another kind of massage, check with your health care practitioner first to be sure there is no risk in using a vibrator.

Pregnant women have reported that vibration is very comforting both for stretched-out bellies and backaches late in pregnancy. Orgasms, whether induced by the vibrator or any other source of stimulation, are not contraindicated for most pregnant women and some find that, especially during the last few months of pregnancy, when their mobility is limited, a vibrator can come in very handy. Women who have a history of pre-term labor or those who have any indication that their labor might start too early should not use vibrators on their bellies, backs or genitals without a specific okay from their doctor or midwife. The vibration could trigger premature uterine contractions.

Keep a battery vibrator handy, though, for the first month or two of your baby's life. Parents report that sometimes fussy infants can be calmed by giving the child gentle back massage with a small battery-operated vibrator or by placing the vibrator, wrapped loosely in a towel, in the baby's crib.

It is not safe to do this if your baby is old enough to unwrap the vibrator or if this could happen by accident, because even a battery-operated vibrator can become quite hot if it vibrates for a long time, especially if it is wrapped in such a way that it can't cool off as it goes. So, if the baby is old enough to roll over, do not leave him or her and the vibrator untended!

Some hospitals use small battery-powered vibrators in the neonatal nursery. They are used on the backs of tiny infants to help the babies cough up fluid that occasionally collects in the lungs. We've often wondered if the hospital staff have found out about the recreational use of these vibrators, too.

10

...And She (or He)
Buzzed Happily Ever After

I NSTRUCTORS OF HUMAN SEXUALITY classes are sometimes accused of leaving "love" out of their courses. A book like this may engender a similar response from some of its readers. I believe that sex and love can, and frequently do, vary independently. One may be a superb lover in the sense that he or she always knows what to do sexually to arouse a partner; this says little or nothing about his or her ability to initiate, build or maintain a loving, intimate relationship, be it casual or committed. Conversely, in many intensely intimate relationships, sex is not terribly important to either person. When deep love and great sex go together, that's wonderful of course, but either one can be terrific all by itself.

This book, other sexual self-awareness materials, vibrators and other sex toys will not make love happen. Where there is sex without love they will make little or no difference in the emotional climate. Where there is love, they may enhance or liven up the sex by augmenting already good verbal and physical communication and contact.

It is currently popular to stress the necessity of loving oneself in order to be able to love another. And, in spite of cultural prohibitions against selfishness and putting oneself first, most people are finding that as their self-esteem improves, their relationships become much more satisfying. In spite of this, mastur-

bation, or making love to oneself, is still seen as a second- or third-rate sexual activity compared to having sex with someone else. Indeed, those who say that their self-sexuality is a valid and important component of their overall sexual expression risk being viewed as abnormal, isolated and self-centered. Never fear. Many men and women are enthusiastic about masturbation; no one I know always prefers it to shared sex. And most say that each one enhances the other.

We often use "love" as a euphemism for sexual activity. In so doing, we can, if we choose, avoid talking about sex at all. But as long as we avoid talk about sex, we are likely to maintain negative attitudes about it. Becoming affirmative about sex inevitably changes our perspective about the functions of sex in our individual makeup and in our relationships. It frees up energy previously expended in keeping up the pretense that we are "nice people" who lack interest in whatever it is that might trigger our lust.

What part can a vibrator play in freeing your sexual energy and helping you become more sex-affirming? First, you will learn something about yourself if you can observe how your current beliefs affect your decision to obtain a vibrator. Second, you can start a new kind of discussion with a friend or lover using vibrators as a topic. Finally, you can bring an entirely new, and most people agree different, sensation into both your self-loving and shared sexual experiences. While you are at it, don't forget to have fun. That's really what it's all about.

About the Authors

JOANI BLANK worked as a sex therapist and sex educator starting in the early 1970s. She taught human sexuality at the community college level, led sexuality workshops for women, and was an active volunteer and trainer at San Francisco Sex Information.

In the spring of 1975 she started Down There Press with publication of *The Playbook for Women About Sex.* Down There Press now publishes the work of other authors as well, and boasts a list of a nearly twenty titles.

In 1977 Joani published the first edition of *Good Vibrations.* She opened her retail store, also called Good Vibrations®, in the same year so that women would have a comfortable and non-threatening environment in which to learn about and buy sex toys and books.

The store and subsequent growth of mail order provided an outlet for her books. In 1988 she started The Sexuality Library, a mail order catalog of sexual self-awareness and enhancement books.

In 1992, Joani and her employees reorganized the growing company as a 100% worker-owned cooperative. She is now recognized as Founder and Publisher Emerita, while continuing to promote the business and pursue her interests in cohousing and community economic development, and enjoying her grandchildren.

Joani is a graduate of Oberlin College and received her MPH (in Public Health Education) from the University of North Carolina at Chapel Hill.

ANN WHIDDEN started her career talking about sex by working as the assistant director at a women's health clinic. She has worked at Good Vibrations® for five years as a sex educator, video reviewer, writer and editor. She writes Good Vibrations®' online advice column, and thinks that vibrators really are a girl's best friend.

Also by Joani Blank

A Kid's First Book About Sex
The Playbook for Kids About Sex
The Playbook for Men About Sex
The Playbook for Women About Sex
Femalia (editor)
First Person Sexual (editor)
I Am My Lover (editor)
Still Doing It: Women & Men Over 60 Write About Their Sexuality
(editor)
Herotica 2 (co-editor, with Susie Bright, NAL/Plume)

Selected Readings

Blank, Joani, editor. *First Person Sexual: Women & Men Write About Self-Loving.* San Francisco: Down There Press, 1996.

Blank, Joani, "Vibrators" entry. In: *Human Sexuality: An Encyclopedia,* Vern and Bonnie Bullough, editors. London: Garland Publishing, 1994.

Califia, Pat. *Sapphistry: The Book of Lesbian Sexuality.* Tallahassee: Naiad Press, 1988.

Davis, Clive, Joani Blank, Hung-Yu Lin and Consuelo Bonillas, "Characteristics of Vibrator Use Among Women." *The Journal of Sex Research 33(4)*: 313-320 (1996).

Dodson, Betty. "Confessions of a Pleasure Junkie." *Forum,* June 1978.

Dodson, Betty. *Sex For One: The Joy of SelfLoving.* New York: Harmony Books, 1987, 1996.

Federal Register, February 26, 1980.

Maines, Rachel. "Socially Camouflaged Technologies: The Case of the Electromechanical Vibrator." *Technology,* June 1989.

Maines, Rachel. *The Technology of Orgasm: "Hysteria," the Vibrator, and Women's Sexual Satisfaction.* Baltimore and London: The Johns Hopkins University Press, 1999.

Maines, Rachel. "The Vibrator and Its Predecessor Technologies," presented at the Four Society Meeting, Pittsburgh, Pennsylvania, October 1986 (Society for the History of Technology, History of Science Society, Philosophy of Science Association, Society for the Social Study of Science).

Morin, Jack. *Anal Pleasure & Health: A Guide for Men and Women,* 3rd rev. ed. San Francisco: Down There Press, 1998.

Semans, Anne and Cathy Winks. *Sex Toy Tales.* San Francisco: Down There Press, 1998.

Swartz, Mimi. "For the Woman Who Has Almost Everything." *Esquire,* July 1980.

Winks, Cathy. *The Good Vibrations Guide: The G-Spot.* San Francisco: Down There Press, 1998.

Books from DOWN THERE PRESS

_____ **Good Vibrations: The New Complete Guide to Vibrators,** Joani Blank. $8.50

_____ **First Person Sexual,** Joani Blank, editor. Women and men share the myriad ways they pleasure themselves. $14.50

_____ **I Am My Lover,** Joani Blank, editor. Artful duotone and B&W photos of twelve women pleasuring themselves. $25.00

_____ **Still Doing It: Women & Men Over 60 Write About Their Sexuality,** Joani Blank, editor. Proof-positive that sex continues indefinitely and infinitely. $12.50

_____ **The Good Vibrations Guide: The G-Spot,** Cathy Winks. The latest on the elusive pleasure spot and female ejaculation. $7.00

_____ **The Good Vibrations Guide: Adult Videos,** Cathy Winks. Brief reviews, interviews of the stars, censorship battles, and an entertaining history of the porn industry. $7.00

_____ **Sex Toy Tales,** Anne Semans and Cathy Winks, editors. Tasty tales incorporating a variety of imaginative sexual accessories. $12.50

_____ **Exhibitionism for the Shy, Show Off, Dress Up and Talk Hot,** Carol Queen. "...a sexual travel guide..." _Libido._ $12.50

_____ **Sex Spoken Here,** Carol Queen and Jack Davis, editors. Cutting-edge erotica from San Francisco writers and poets. $14.50

_____ **Femalia,** Joani Blank, editor. Thirty-two stunning color photographs of vulvas by four photographers, for aesthetic enjoyment and edification. $14.50

_____ **Herotica: A Collection of Women's Erotic Fiction, 10th Anniversary Edition,** Susie Bright, editor. The first volume in the ground-breaking series "...explores the outer boundaries of erotica." _Lambda Book Report._ $11.00

_____ **Herotica 6,** Marcy Sheiner, editor. Hot sex in committed relationships. $12.50

_____ **Anal Pleasure & Health, rev. 3rd ed.,** Jack Morin, Ph.D. The definitive guide for women and men to enjoying anal stimulation, with a new chapter on power dynamics and finding sex-positive health practitioners. $18.00

_____ **Sex Information, May I Help You?,** Isadora Alman. "An excellent model on how to speak directly about sex." _San Francisco Chronicle._ $9.50

_____ **Erotic by Nature,** David Steinberg, editor. A luscious volume of photos, line drawings, prose and poetry for, by and of women and men. Clothbound. $45.00

_____ **The Playbook for Women About Sex,** Joani Blank. $4.50

_____ **The Playbook for Men About Sex,** Joani Blank. Activities to enhance sexual self-awareness. $4.50

Catalog — free with purchase of any book, else send $2

❑ Good Vibrations Mail Order. Many of the wonderful toys, books and videos available in the San Francisco vibrator store.

Buy these books from your local bookstore, call toll-free at 1-800-289-8423, log on to www.goodvibes.com/dtp/dtp.html, or mail this page with your name and street address:

Down There Press, 938 Howard St., #101, San Francisco CA 94103

Include $13.45 for the first book ordered and $1.00 for each additional book. California residents please add sales tax. Please give us your street address for UPS shipping.